Acrylics
Workshop

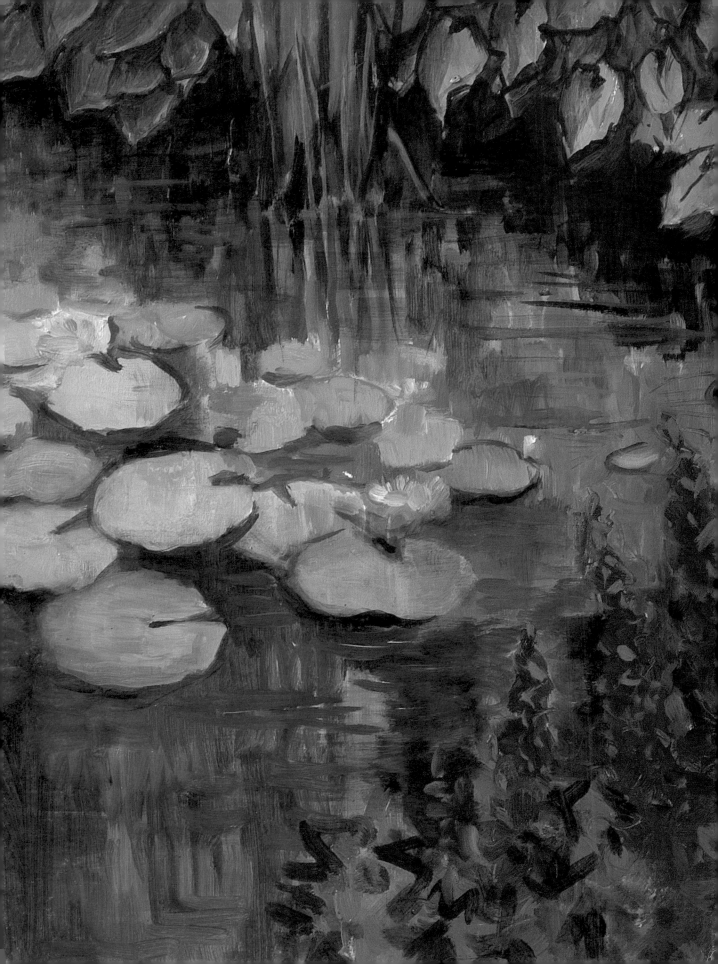

Acrylics
Workshop

Phyllis McDowell

DK Publishing

LONDON, NEW YORK, MELBOURNE,
MUNICH, DELHI

Project Editor Kathryn Wilkinson
Project Art Editor Anna Plucinska
DTP Designer Adam Walker

Managing Editor Julie Oughton
Managing Art Editor Christine Keilty
Production Controller Shane Higgins
US Editor Jenny Siklós
Photography Andy Crawford

**Produced for Dorling Kindersley
by Design Gallery
Art Editor** Vanessa Marr
Project Editor Lynn Bresler
Managing Editor David Garvin

First American Edition, 2006

Published in the United States by
DK Publishing, 375 Hudson Street,
New York, New York, 10014

06 07 08 09 10 9 8 7 6 5 4 3 2 1

A Cataloging-in-Publication record for this book
is available from the Library of Congress.

ISBN-13: 978-0-7566-2207-7

ISBN-10: 0-7566-2207-7

DK books are available at special discounts for bulk
purchases for sales promotions, premiums, fund-raising,
or educational use. For details, contact: DK Publishing
Special Markets, 375 Hudson Street, New York,
NY 10014 or SpecialSales@dk.com

Printed and bound in China by
Hung Hing Offset Printing Company Ltd

Discover more at
www.dk.com

Contents

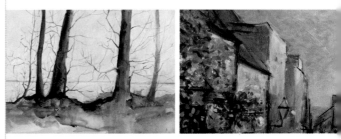

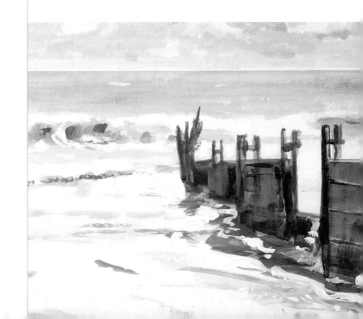

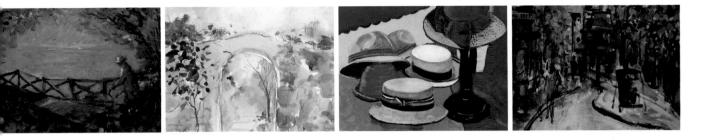

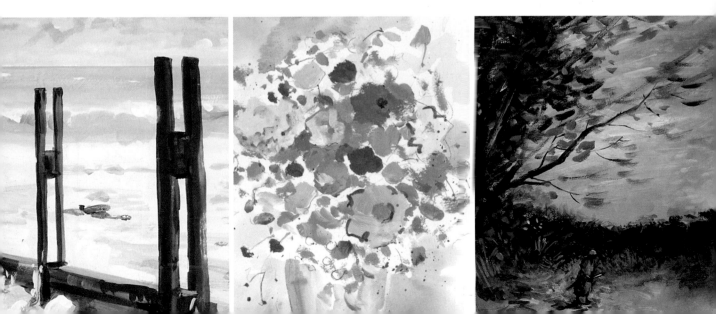

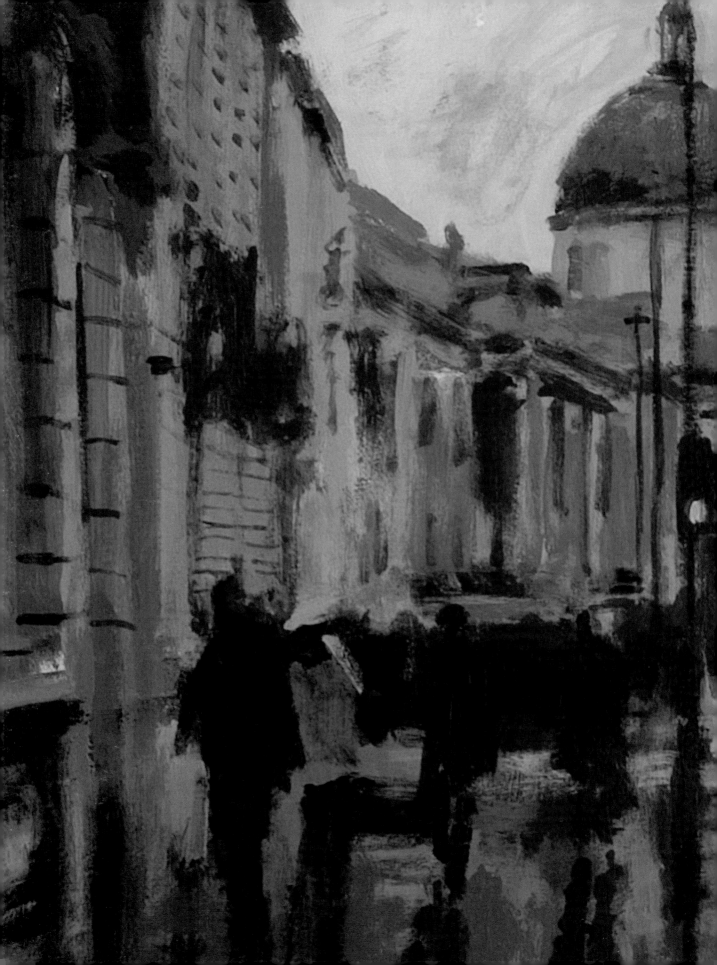

Introduction

Acrylics provide a great opportunity to create exciting pictures, for beginners and professionals alike. They offer brilliance of color, speed and convenience of use, and, above all, versatility. You can use acrylics to produce precise, detailed paintings, or adventurous, abstract pieces. You can use them on a wide range of surfaces, and mistakes can be easily corrected.

Transparency, richness, and speed

Whatever the subject or the mood you want to create in your painting, acrylics allow you to use a whole range of techniques. Because these paints are water-based, they can be used in a fluid way to achieve the transparency of a summer sky, the delicacy of a petal,

or the calligraphic detail of a cat's whiskers. On the other hand, when applied thickly, they can capture effects as varied as the swirl of stormy seas, the texture of a horse's mane, or the rich colors of an autumn woodland. Diluted, acrylics can give you a perfectly smooth, flat wash; squeezed straight from the tube, they build a luscious impasto; and mixed with the many additives available, the surface can be sculptured, roughened, textured, or glazed. Acrylics also have the advantage of speed and ease of use: you can create pleasing pictures quickly knowing you can readily correct any mistakes. So, if part of a painting is not to your liking, you can paint it out and repaint it in minutes. If you want to balance a composition, acrylics allow you to make last-minute changes easily—so you can correct perspective, for example, or add highlights at any stage. Equally important are the practicalities of working with acrylic paints. They are compact and easy to store, and they are easy to carry with you if you are painting outdoors. The colors do not fade and the surface of acrylic paintings is tough, so not easily damaged. Acrylics don't have an odor, so you can paint anywhere, even in the kitchen; equipment can be cleaned with water and household soap.

Learning about acrylics

This book aims to guide the beginner through all the stages of making exciting pictures in acrylics. There is advice on buying materials and how to use them to the best advantage. A strong foundation of basic techniques, advice on how to mix colors, and how to create pleasing compositions are all introduced in easy stages, with opportunities to practice in order to build understanding and confidence. This hands-on approach means you start painting right away and have the satisfaction of producing work you can really be pleased with. The four chapters that follow on from the materials and techniques section introduce increasingly sophisticated ways of exploiting acrylics, with examples of how different subjects have been treated by various artists over the years. The 12 projects show you, step by step, how the techniques you have practiced can be combined to construct appealing paintings—using color, perspective, lighting, and contrast to give realism and impact. As you start to produce more and more exciting effects in acrylics, your skills will increase—as will the pleasure you obtain from exploring the huge range of opportunities provided by this versatile medium.

Materials and Techniques

Paint and other materials

There is an ever-increasing range of acrylic paints available, but there is no need to buy a lot of colors. It is a good idea to start with a limited palette and experiment to see which colors you can mix. Acrylic paints are available in tubes, tubs, and bottles. The most convenient to use are tubes. They are less bulky, the color is always fresh and clean, and you can easily control the amount of paint you squeeze out.

RECOMMENDED COLORS

The 12 paints below make a good basic starter palette. Using these colors, you will be able to mix limitless variations of color. The list includes primary colors—two reds, two yellows, and three blues; one of each of the secondary colors—orange, green, and purple; along with magenta and white. You don't need a black—this can be mixed up.

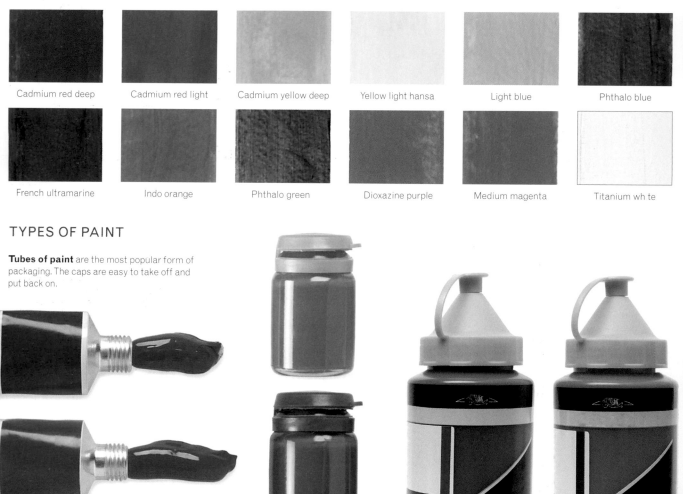

| Cadmium red deep | Cadmium red light | Cadmium yellow deep | Yellow light hansa | Light blue | Phthalo blue |
| French ultramarine | Indo orange | Phthalo green | Dioxazine purple | Medium magenta | Titanium wh te |

TYPES OF PAINT

Tubes of paint are the most popular form of packaging. The caps are easy to take off and put back on.

Tubs of paint may be used for large pieces of work, such as a mural painting. The paint is scooped from the tub.

Bottles of paint stand upright. The paint is squeezed out through a nozzle. Bottled paint is usually more liquid.

OTHER MATERIALS

There is no need to buy a huge number of brushes—the range below will enable you to achieve a wide variety of effects. As well as paint, paper, and brushes, your basic painting kit should include a pencil, an eraser, masking tape, paper towels, a paint rag (cotton toweling is best), and large jars of water for mixing paints and cleaning brushes.

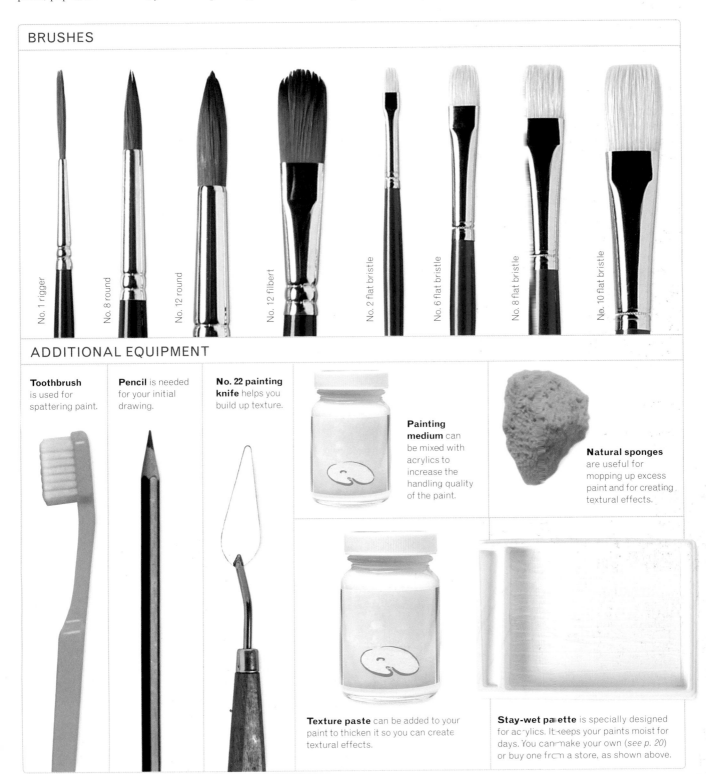

BRUSHES

No. 1 rigger

No. 8 round

No. 12 round

No. 12 filbert

No. 2 flat bristle

No. 6 flat bristle

No. 8 flat bristle

No. 10 flat bristle

ADDITIONAL EQUIPMENT

Toothbrush is used for spattering paint.

Pencil is needed for your initial drawing.

No. 22 painting knife helps you build up texture.

Painting medium can be mixed with acrylics to increase the handling quality of the paint.

Natural sponges are useful for mopping up excess paint and for creating textural effects.

Texture paste can be added to your paint to thicken it so you can create textural effects.

Stay-wet palette is specially designed for acrylics. It keeps your paints moist for days. You can make your own (*see p. 20*) or buy one from a store, as shown above.

Supports

One of the many advantages of acrylic paint is that you can use it on a wide variety of paper and other material, provided the surface is non-greasy. Supports for acrylic paint range from cartridge paper to watercolor paper, canvas board to cardboard. They all offer a different surface, which affects the way the paint is absorbed and how the painting looks – so spend some time experimenting.

TYPES OF SUPPORT

Acrylic paper is a lightweight support made for use with acrylic paint. Highly diluted acrylic is best used on watercolor paper. Other supports include thick drawing paper, newspaper, cardboard, mountboard, hardboard, canvas board, and stretched canvas. If areas are left unpainted, the color of some cardboards and mountboards can add to the painting.

Acrylic paper is available in pads of varying sizes. It has an embossed finish and textured surface similar to canvas.

Watercolor paper is ideal for acrylic painting. It comes in varying weights and surfaces, all suitable for acrylics. It is also available in tinted shades.

Cardboard is a sympathetic surface. The color of the board can be used to contribute to a color scheme.

Canvas can be bought already primed and stretched over a frame, in a variety of sizes and proportions. It comes in different textures.

Canvas board is a handy alternative to stretched canvas. The primed canvas is stuck to a panel, giving a firm painting surface.

PAINT ON SUPPORTS

The surface you choose to work on has a noticeable effect on the finished work. These five paintings of waterlilies were all composed in the same way, but painted on five different surfaces—and each result is markedly different.

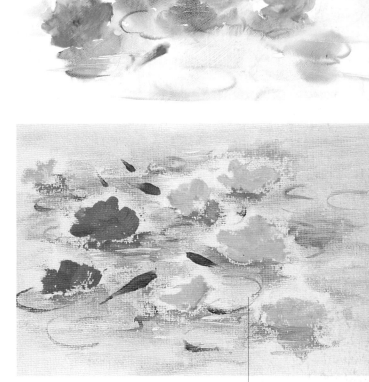

Acrylic paint can be applied thickly on canvas.

Stretched canvas This warm surface seems to welcome the paint. The slight spring of the canvas gives vitality to the brushwork. You can use thin or thick paint.

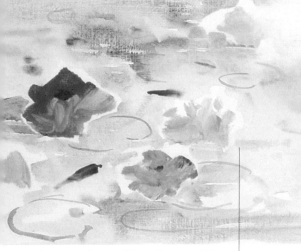

Acrylic paper Washes slide easily across this rather slithery surface and tend to come to an abrupt end. The addition of water increases the fluidity and softens the washes.

The washes are softened with water.

Canvas board This is a hard, firm surface that invites a bold, fearless approach. The tough surface makes it possible to overpaint and make changes without anxiety.

The texture of the board is visible.

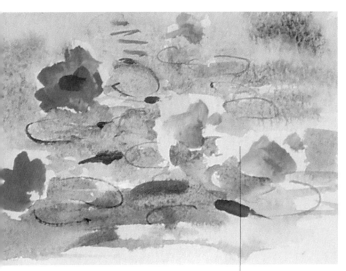

Tinted watercolor paper The warm oatmeal color of this paper helps unify this painting. You can apply thin washes, so the paper color shows through, or use opaque paint.

Unpainted areas give an overall color.

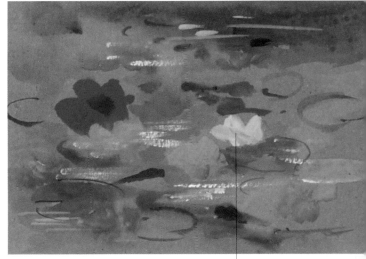

Cardboard This cheap, accessible paint surface invites experimentation. It is tough and rugged, and takes heavy paint. The cardboard's strong color modifies transparent washes.

Light, opaque colors stand out from the toned background.

Brushes and painting knives

A wide range of brushes is available to use with acrylic paint. You can use brushes that are recommended for oil or watercolor, but use the cheaper synthetic brushes rather than the more expensive sable ones, because acrylic paint tends to be harder on brushes than other painting media. You can also mix and apply acrylic paint with a painting knife, which has a cranked handle to lift it from the painting surface.

BRUSH AND PAINTING KNIFE SHAPES

Brushes and painting knives come in different shapes and sizes. Brushes can be round, flat, filbert, or rigger, and are numbered: the larger the brush, the higher the number. Use the recommended brushes and knife (*see p.13*) to create a wide range of strokes from fine lines to broad washes, as shown below. Each brush or knife lends itself to specific effects.

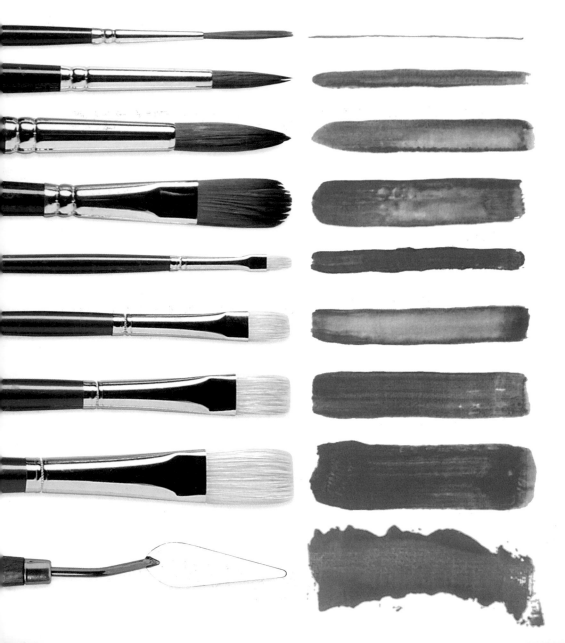

No. 1 rigger is perfect for delicate, sensitive, fine lines.

No. 8 round is a handy general brusn for drawing and detail.

No. 12 round is good for larger areas that need definite contour.

No. 12 filbert is suitable for soft, rounded marks and shapes.

No. 2 flat bristle is used to make small, stabbing brushstrokes.

No. 6 flat bristle is useful for intermediate brushstrokes.

No. 8 flat bristle holds more paint and is ideal for covering larger areas.

No. 10 flat bristle is used for covering, and laying in broad areas.

No. 22 painting knife is used both for mixing and applying paint.

HOW TO HOLD A BRUSH OR PAINTING KNIFE

Acrylic brushstrokes should be fluid and spontaneous. The brush should be held lightly in the hand, with fingers and wrist in a relaxed position, allowing the brush to perform.

A variety of brushstrokes will result if you vary the angle of the brush, the pressure applied, and the speed. Never fiddle with a brushstroke once it is down on the paper or board.

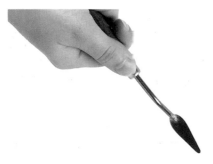

To work with the painting knife, you need to grip it with a closed fist as if you were working with a trowel.

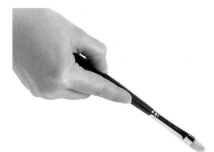

To hold a flat bristle brush, place your hand over the handle with the index finger outstretched, and support from underneath with your thumb.

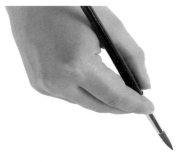

To make a variety of strokes using a round brush, hold it with your hand close to the brush head, as if you are holding a pencil.

Varying strokes

To create a smooth stroke, push the brush down evenly as you move it over the paper.

To make a long, fluid stroke, use the tip of the brush and apply even pressure.

To make a leaflike mark, pull the brush slowly across the paper, lifting off as the leaf tapers.

To gradually lighten a brush stroke, slowly lift the brush off as you move across the paper.

To create a textured effect, use a fairly dry brush and drag it quickly across the paper.

To make a pressurized stroke, push the brush down hard and then release it quickly.

To give the impression of form, flip the brush over as it travels over the paper.

Brushstrokes

Discover the variety of effects that you can achieve by trying out, and experimenting with, your brushes; the range of marks you can make using round, flat, or rigger brushes is shown below. The more you practice, the more you will improve your brush control and your confidence. Vary the speed, pressure, and direction of the marks to create unexpected and unusual results.

BRUSH EFFECTS

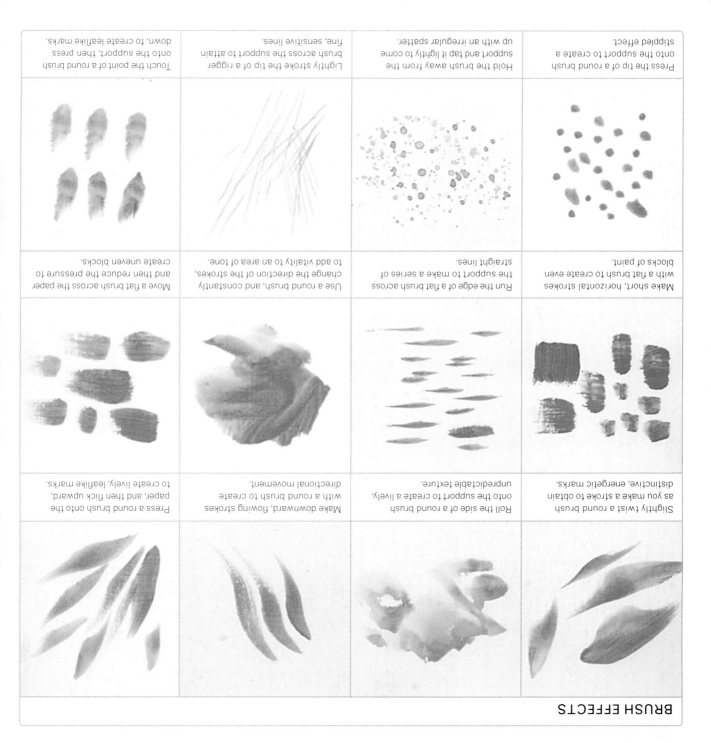

Press the tip of a round brush onto the support to create a stippled effect.

Hold the brush away from the support and tap it lightly to come up with an irregular spatter.

Lightly stroke the tip of a rigger brush across the support to attain fine, sensitive lines.

Touch the point of a round brush onto the support, then press down, to create leaflike marks.

Make short, horizontal strokes with a flat brush to create even blocks of paint.

Run the edge of a flat brush across the support to make a series of straight lines.

Use a round brush, and constantly change the direction of the strokes, to add vitality to an area of tone.

Move a flat brush across the paper and then reduce the pressure to create uneven blocks.

Slightly twist a round brush as you make a stroke to obtain distinctive, energetic marks.

Roll the side of a round brush onto the support to create a lively, unpredictable texture.

Make downward, flowing strokes with a round brush to create directional movement.

Press a round brush onto the paper, and then flick upward, to create lively, leaflike marks.

APPLYING STROKES

A few uncomplicated markmaking techniques can be used to create simple images. Try out the individual marks that are painted on this page, and then put them together to make a vase, a hedgehog, and a tree.

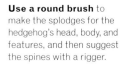

Use a round brush to make the splodges for the hedgehog's head, body, and features, and then suggest the spines with a rigger.

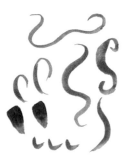

Apply calligraphic strokes with a round brush to suggest an ornate vase. Hold the brush loosely so the brushstrokes flow rhythmically.

Use simple dabs of a moist sponge and the splatter from a toothbrush to give the impression of foliage. Then add the tree trunk with a rigger.

Fast-drying acrylics

Acrylic paints dry fast. This means you can rework areas of your painting almost immediately. But beware—the paints on your palette also dry out exceptionally quickly. And once dried, they are useless. So it is best to use a stay-wet palette—this has a damp layer under the mixing surface to keep the paints moist. You can buy a stay-wet palette at art stores or make one yourself.

HOW TO MAKE A STAY-WET PALETTE

It's easy to make your own stay-wet palette to the exact size you want. All you need is a shallow plastic tray, some capillary matt (available from a florist or nursery), waxed paper, and plastic wrap. Some artists prefer mixing colors on brown baking parchment (as shown below)—but if you prefer a white surface, just use standard waxed paper instead.

Shop bought A stay wet-palette bought from a shop usually comes with a white mixing surface.

MAKING A STAY-WET PALETTE

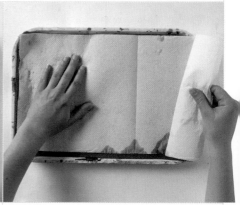

For the bottom layer of your stay-wet palette, cut the capillary matt to the size of your tray. Then tuck it snugly into the tray.

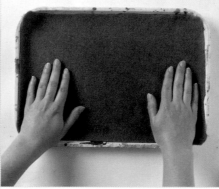

Pour water onto the matt and then press it down to ensure that the water is fully absorbed and evenly distributed.

When the whole of the matt darkens with the water, cover it completely with three layers of paper towel.

Press the layers of paper towel down onto the matt with your hands. Don't worry if the paper towel becomes wrinkled.

Cut the baking parchment (or waxed paper) to a larger size, so that it covers the walls of the tray. Then press it down over the paper towel.

Now you can mix paints on the parchment. When you take a break, cover the palette with plastic wrap so the paints don't dry out.

PAINTING OVER THE TOP OF ACRYLICS

As acrylics dry so quickly, it is easy to correct mistakes almost instantly. So that you can cover areas you want to change, make sure you add white to your mixes to obtain paint mixes that are completely opaque.

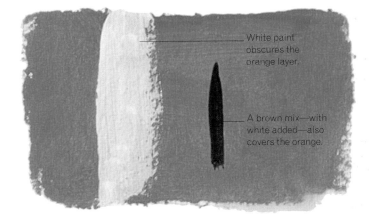

White paint obscures the orange layer.

A brown mix—with white added—also covers the orange.

Covering up Here, you can see how an orange layer of paint has been obscured with white paint and a brown opaque mix.

REWORKING A PAINTING

This still life study shows how easily you can repaint acrylics. The initial painting is on the left, and the finished reworked painting on the right. The artist simply waited a minute or two for the colors to dry and then repainted parts of the image she wanted to change.

The pale lilac has been painted over the rather unsightly pear stalk.

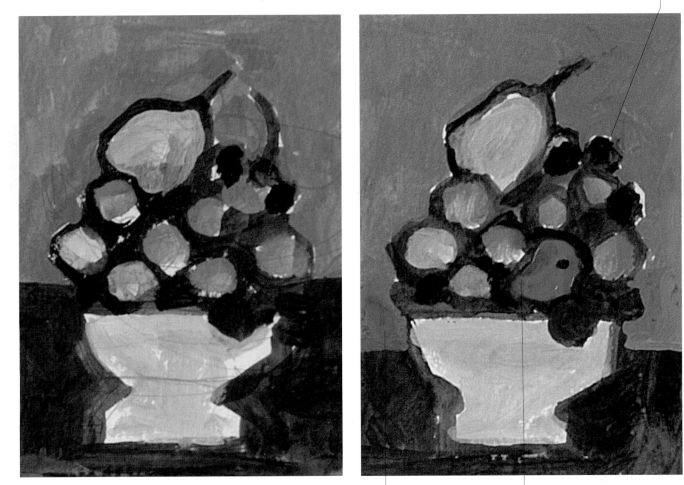

The pale lilac of the background has been extended down, over the table top, so that the bowl of fruit stands out more prominently.

An orange has been added on top of the green fruit to give a bright focal point.

Color wheel

The color wheel is the traditional way of illustrating how the six main colors—red, purple, blue, green, yellow, and orange—relate to each other. The primary colors—red, blue, and yellow—cannot be mixed from any other colors. When two primary colors are mixed together, they produce a secondary color—purple, green, or orange. Try mixing pairs of primary colors on scrap paper before you start painting.

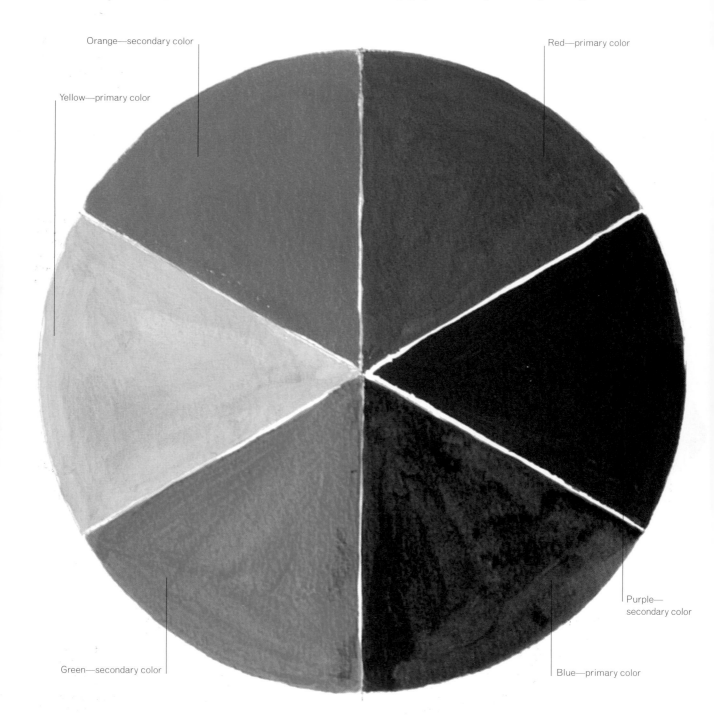

Orange—secondary color

Red—primary color

Yellow—primary color

Purple—secondary color

Green—secondary color

Blue—primary color

MIXING TWO PRIMARY COLORS

When you mix pairs of primary colors together, you create various kinds of secondary colors, depending on the pigments you use. For vibrant secondary colors, use pigments that are close to each other on the color wheel. For instance, if you want a sharp, bold green, mix a greenish blue and a greenish yellow. For a subtler green, choose pigments that are farther away from each other on the color wheel—so use a purplish blue and an orangey yellow.

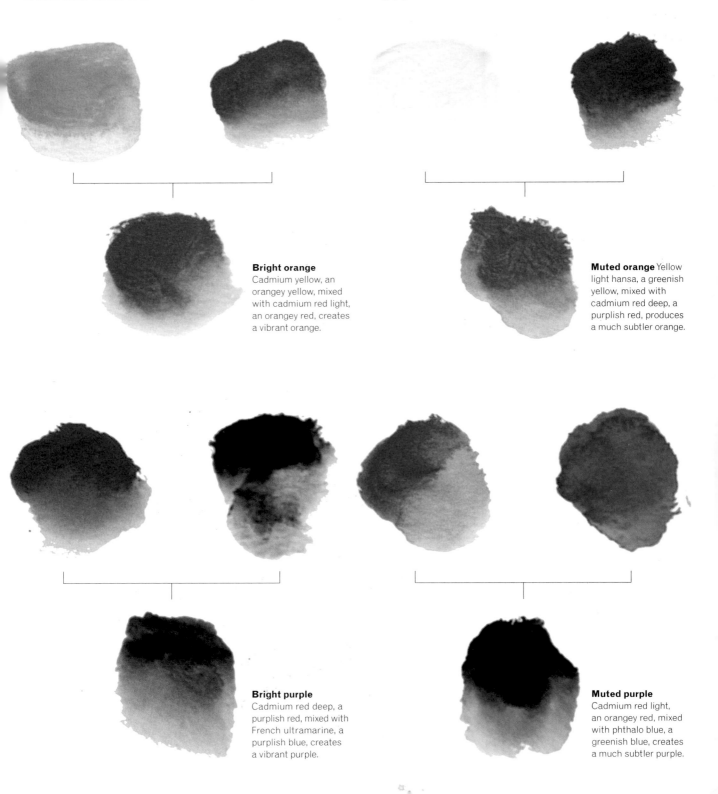

Bright orange
Cadmium yellow, an orangey yellow, mixed with cadmium red light, an orangey red, creates a vibrant orange.

Muted orange Yellow light hansa, a greenish yellow, mixed with cadmium red deep, a purplish red, produces a much subtler orange.

Bright purple
Cadmium red deep, a purplish red, mixed with French ultramarine, a purplish blue, creates a vibrant purple.

Muted purple
Cadmium red light, an orangey red, mixed with phthalo blue, a greenish blue, creates a much subtler purple.

Color mixing

Getting the right colors for your painting is a simple, enjoyable process. If the manufactured color is exactly what you want, you can apply it to your picture without any mixing. However, often you will have to add another color to adjust the hue. For example, if the green is too blue, you need to add some yellow. Start with small amounts and watch the mix as you go until you get the exact color you need.

METHODS OF MIXING PAINTS

There are three basic ways of mixing paint. Mixing on the palette is the safety-first method—you make sure you get exactly the right color before applying it. Mixing on the support is a quicker approach, and it encourages spontaneity. Mixing on the brush is for the adventurous. The colors don't blend evenly, so you'll get some exciting, and unexpected, passages of paint.

HOW TO MIX ON THE PALETTE

Squeeze out blue and yellow on your palette. Use a brush to move some yellow.

Pick up some blue and stir it into the yellow. Add more blue or yellow until you get the color you require.

Continue mixing the colors with the brush until they are completely blended.

You are now ready to apply the mix to the painting, knowing you have the exact color you want.

HOW TO MIX ON THE SUPPORT

With your brush, apply a generous amount of yellow directly onto your support.

Load your brush with blue and apply it onto the yellow with a stroking motion.

Blend the two colors with vigorous turns of the brush. Adjust the color by adding more yellow or blue.

The final green mix is actually on your painting, ready to be stroked into the subject matter you want.

HOW TO MIX ON THE BRUSH

With a twisting motion, roll the brush into the yellow paint without touching the blue paint.

With the brush loaded with yellow, gently roll it into the blue so you get both colors on the brush.

Apply the paint onto the support. Be prepared for some spontaneous color effects.

The colors do not evenly mix, creating wonderful strokes that go from yellow to green to blue.

MIXING GREENS

How do you do justice to the infinite variety of greens in nature? You could buy all the ready-made greens available and still find yourself wanting. The secret is to spend time mixing paint. You can create a wide range of greens by mixing blues with yellows and then changing the proportions of each color in the mix. Also try adding touches of orange or red to create more subtle greens. And try mixing orange or red with the phthalo green in your starter palette.

VARIETIES OF GREEN

Phthalo blue and yellow light hansa are both transparent and carry a hint of green. When mixed, they produce a pure, transparent green.

French ultramarine is transparent with a hint of red. When mixed with yellow light hansa, the resulting green is transparent and earthy.

Cadmium yellow deep is an opaque color carrying a hint of red. Mixing it with phthalo blue results in a semi-opaque, rustic green.

Phthalo green is a bright, transparent bluey-green. The addition of cadmium red light turns it into a rich green, commonly seen in nature.

Phthalo green and cadmium red deep are transparent colors with a hint of blue. Mixing them results in a rich, transparent dark green.

TREE STUDY

Varying the color of the foliage has brought this tree study to life. Bluey-greens are used with yellowy-greens; dark shades with pale ones; and fresh, transparent washes with opaque mixes (some including titanium white). This variety stimulates the eye, encouraging it to move around the picture. Think how uninteresting the tree would be if it was painted with one green.

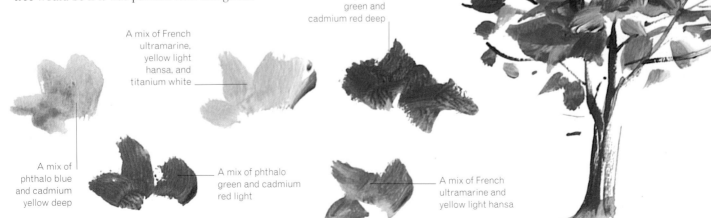

A mix of phthalo green and cadmium red deep

A mix of French ultramarine, yellow light hansa, and titanium white

A mix of phthalo blue and cadmium yellow deep

A mix of phthalo green and cadmium red light

A mix of French ultramarine and yellow light hansa

Neutrals and darks

The color wheel consists of an array of pure, bright colors because there are never more than two primary colors mixed together. However, you also need dark, neutral colors in your painting. These can be attained by mixing two complementary colors together—the complementary of any secondary color is the primary color that it does not contain—or by mixing all three primary colors together.

COMPLEMENTARY COLORS

On the color wheel (see p. 22), you can see that red is opposite green, yellow is opposite purple, and blue is opposite orange. These opposites are known as complementary colors.

Placed side by side in a painting, complementary colors seem to become more vibrant and intense, but when they are mixed together, they create subtle grays and browns.

Yellow and purple

The muted spine of the book is a mix of purple and yellow.

The yellow book stands out against the purple background.

Blue and orange

The muted hull of the boat is a mix of blue and orange.

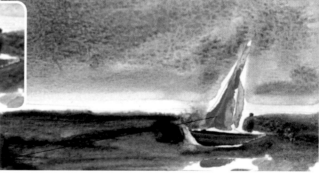

The orange sail stands out against the blue water and sky.

Red and green

The muted darker foliage is a mix of red and green.

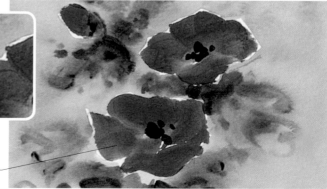

The red flowers stand out against the green foliage.

DARKS WITH PRIMARY COLORS

It is possible to buy black and brown acrylic paint, but you will get far more satisfying results by mixing all three primary colors in varying proportions. This method enables you to mix a much more lively range of blacks and browns than you could ever get in the art supply stores.

Yellow light hansa

Cadmium red deep

Phthalo blue

Transparent black Yellow light hansa and phthalo blue are transparent colors which, when mixed with the cadmium red deep, produce a transparent black.

Cadmium yellow deep

Cadmium red light

French ultramarine

Warm brown The opaque quality of the cadmium yellow deep, mixed with the cadmium red light, dominates the French ultramarine to make a dark brown.

Cadmium yellow deep

Cadmium red deep

Phthalo blue

Opaque black The mix of cadmium yellow deep and cadmium red deep is overpowered by the dominant phthalo blue, resulting in a rich, opaque black.

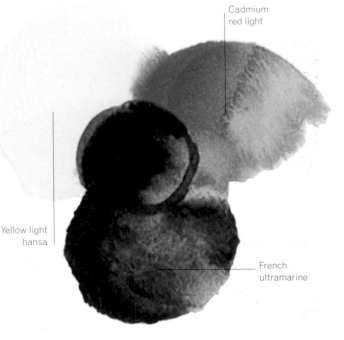

Cadmium red light

Yellow light hansa

French ultramarine

Transparent brown The combination of yellow light hansa, cadmium red light, and French ultramarine results in a warm transparent brown.

Lightening and darkening

Paint mixing is not just about getting the right color, it's also about getting the right shade. So once you have mixed a color, you may need to lighten or darken it. To lighten, simply add water, which increases the transparency of the paint, or add white paint, which makes the paint more opaque. To darken, mix in the complementary color. But beware, the color varies depending on the complementary you use. For example, phthalo blue darkens indo orange in a different way to French ultramarine.

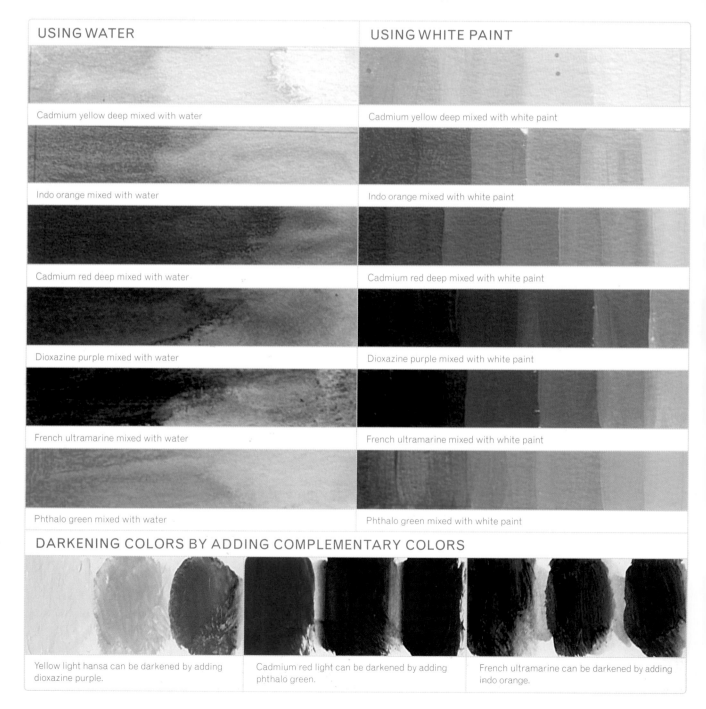

USING WATER

Cadmium yellow deep mixed with water

Indo orange mixed with water

Cadmium red deep mixed with water

Dioxazine purple mixed with water

French ultramarine mixed with water

Phthalo green mixed with water

USING WHITE PAINT

Cadmium yellow deep mixed with white paint

Indo orange mixed with white paint

Cadmium red deep mixed with white paint

Dioxazine purple mixed with white paint

French ultramarine mixed with white paint

Phthalo green mixed with white paint

DARKENING COLORS BY ADDING COMPLEMENTARY COLORS

Yellow light hansa can be darkened by adding dioxazine purple.

Cadmium red light can be darkened by adding phthalo green.

French ultramarine can be darkened by adding indo orange.

SKIN TONES

To render skin tones, you need lots of color mixes in lots of shades. To paint this portrait, for instance, the mixes varied from peachy pinks, to rich dark browns, to golden oranges, to neutral grays as shown in the color mixes on the right. To attain lighter shades, white paint was added to some of the mixes. For dark and neutral colors, complementary colors were used.

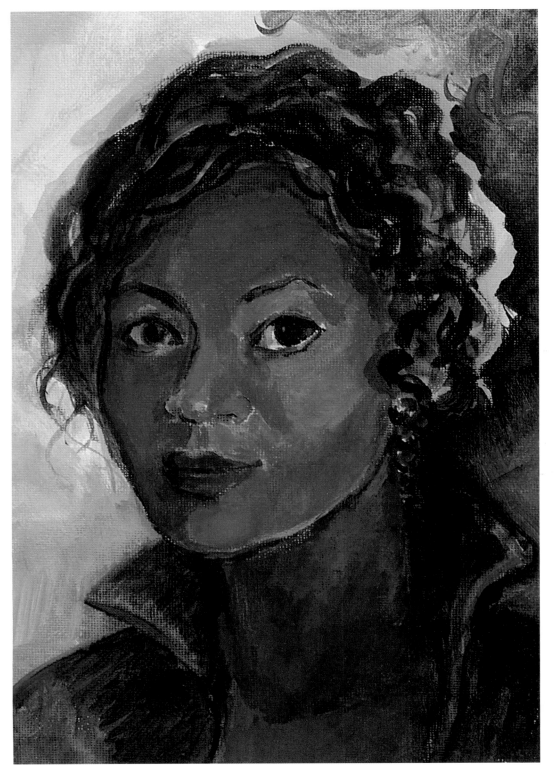

Color mixes

Indo orange and titanium white

Indo orange, phthalo green, and titanium white

Indo orange, cadmium red deep, French ultramarine, and titanium white

Cadmium yellow deep, indo orange, French ultramarine, and titanium white

Indo orange, French ultramarine, and titanium white

Cadmium red deep, phthalo green, and titanium white

Cadmium red deep, cadmium red light, French ultramarine, and titanium white

Cadmium red deep, cadmium red light, and phthalo green

Cadmium red deep and dioxazine purple

Glazing

Glazing involves painting a transparent wash over dry paint, so the color of the underlying layer is modified. In effect, it is another way of color mixing, using two colors to create a third one, with the advantage of adding a magical depth and luminosity to your painting. Acrylics are perfect for glazing. They dry fast, so you can glaze areas quickly and efficiently, and you can build up as many layers of glazes as you want.

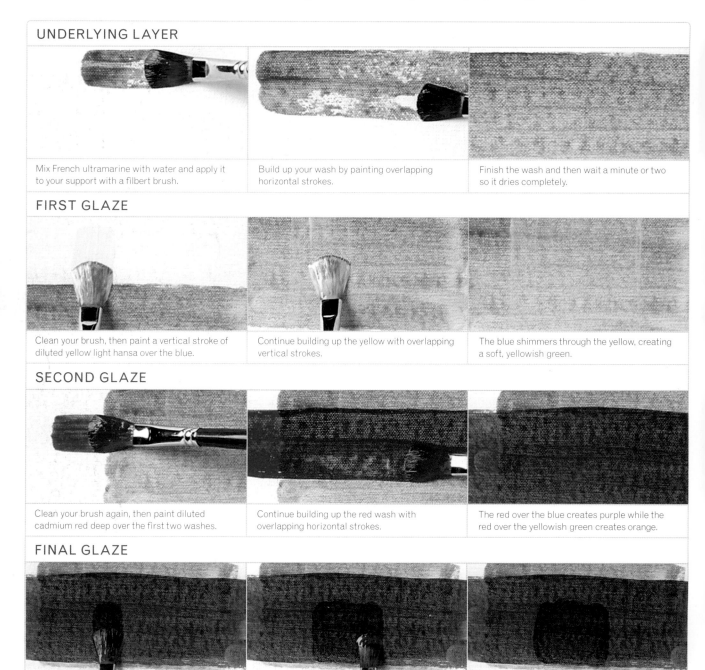

UNDERLYING LAYER

Mix French ultramarine with water and apply it to your support with a filbert brush.

Build up your wash by painting overlapping horizontal strokes.

Finish the wash and then wait a minute or two so it dries completely.

FIRST GLAZE

Clean your brush, then paint a vertical stroke of diluted yellow light hansa over the blue.

Continue building up the yellow with overlapping vertical strokes.

The blue shimmers through the yellow, creating a soft, yellowish green.

SECOND GLAZE

Clean your brush again, then paint diluted cadmium red deep over the first two washes.

Continue building up the red wash with overlapping horizontal strokes.

The red over the blue creates purple while the red over the yellowish green creates orange.

FINAL GLAZE

Clean your brush again and add diluted phthalo blue on top of the orange.

Paint a small square of phthalo blue on top of the orange.

The resulting color is a dark, muted green, perfect for shadow areas.

BLUE ON BLUE

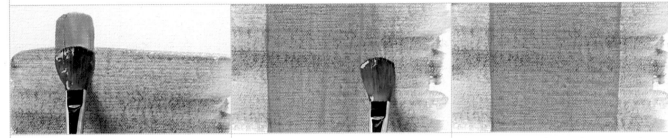

Paint a horizontal wash of French ultramarine, let it dry, then paint dilute phthalo blue on top.

Extend the phthalo blue wash with overlapping vertical strokes.

Together, the two colors create an aquamarine, ideal, for example, for a swimming pool.

YELLOW ON BLUE

Let the phthalo blue dry, then apply dilute yellow light hansa over the two underlying layers.

Build up the yellow light hansa with overlapping horizontal strokes.

The yellow combines with the blue underlying layers to create muted yellowish greens.

USING GLAZING

Here, glazes are used to create the patterning on the goldfish. Moreover, building up dark glazed areas, using layers of indo orange and medium magenta, creates shadow tones on the fish. This helps suggest their three-dimensional forms.

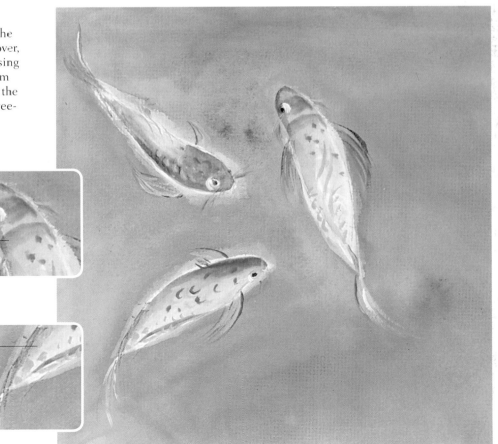

A glaze of indo orange on medium magenta

A glaze of phthalo blue on cadmium yellow deep

Creating textures

A tactile, textured surface can bring a painting alive— and it is easily achieved in acrylics. For subtle textures, use the dry brush technique, which involves applying sticky paint with a delicate touch. For bolder effects, try texture paste, which is usually applied with a painting knife. A lot of texture paste allows you to make sculptural effects. For very fine textures, thin out your paint with painting medium.

DRY BRUSH TECHNIQUE

Dry brushwork lets you attain broken, textured strokes of color. Mix up sticky paint, with little or no water added, and then lightly brush it across your support. It is best to use a support with a prominent "tooth," such as canvas or rough watercolor paper.

The tooth of the support shows through.

Dry, sticky paint only adheres to the raised parts of the textured support, making it perfect for feathers.

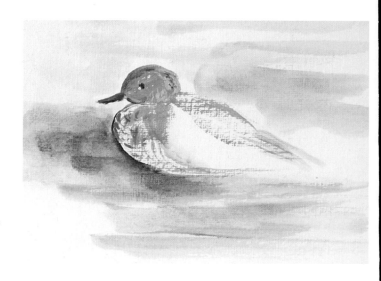

TEXTURE PASTE

For really thick, gungy textures—known as impasto—use texture paste. It can be used directly on your support or added to your paint, and is best applied with a knife. Try it with all kinds of subject matter. When textured, clouds really look three-dimensional and stand out from the sky, and buildings look great if you capture something of their actual texture in the paint.

Texture paste applied directly to the support and then painted over.

Texture paste mixed with paint first and then applied to the support.

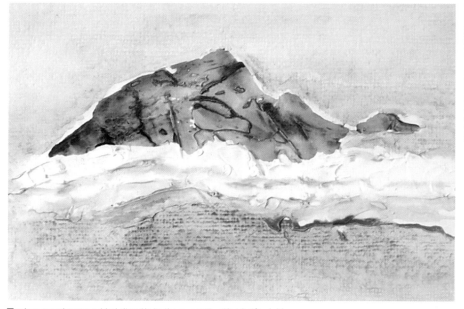

Texture paste was added directly to the support with a knife. A blue-green wash was then added over the rock and a thin blue one over part of the foam.

THICK AND THIN

Acrylic is a versatile, tough medium. You can create wonderfully watery textures and then add thick paint on top or start with a thick, opaque layer and superimpose thin washes.

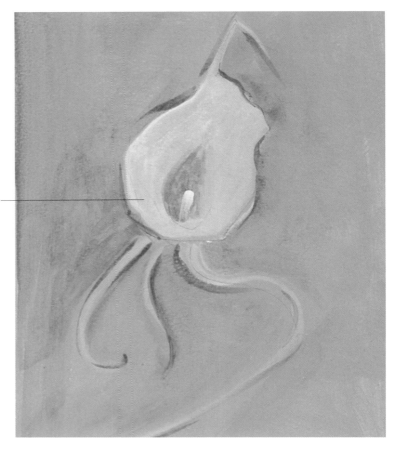

Titanium white, diluted with painting medium, is superimposed on thick paint.

Paint thinned with painting medium creates delicate washes, revealing the background color.

Thin over thick In the painting on the right, a thick, opaque color was painted with a mix of phthalo green and light blue. The flower was added with thin layers of semi-transparent color.

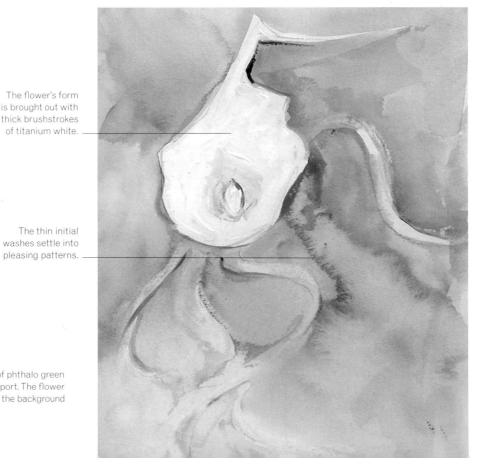

Thick, dry paint allows you to create textured brushstrokes.

The flower's form is brought out with thick brushstrokes of titanium white.

The thin initial washes settle into pleasing patterns.

Thick over thin Here, highly diluted washes of phthalo green and dioxazine purple were flooded onto the support. The flower was painted with thick, neat titanium white after the background washes had dried.

Composition

It is important to plan a painting before getting started. You need to frame your subject so all the component parts sit comfortably. In particular, you need to be aware of the focal points of your composition, placing them in the center of your picture can look a little static, while placing them near the edge can look unbalanced. Instead, use the rule of thirds to put them in the most powerful positions.

VIEWFINDER

A basic viewfinder can be made easily by holding two L-shaped pieces of posterboard to form a rectangle in front of your subject. The size and shape of the frame may be altered by moving the pieces in and out. The frame that you choose will help dictate the format of paper you use, as seen below.

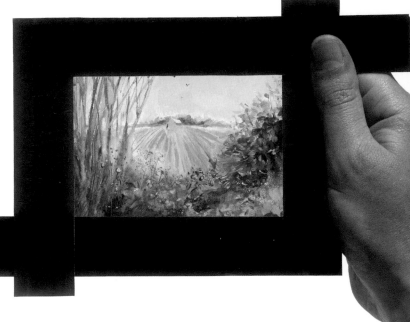

Move the corners in or out to frame your subject

FORMAT

A vital part of composition is choosing which format—the shape of paper—to use. The three paintings below demonstrate how the format can direct attention to different areas of the painting.

The formats are portrait (vertical rectangle), landscape (horizontal rectangle), and square, but you could also try a circular, oval, or panoramic (long horizontal rectangle) format.

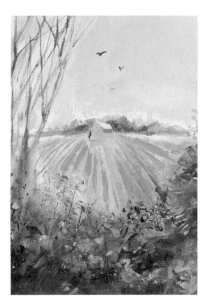

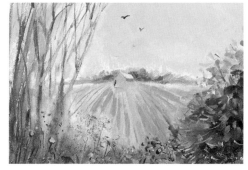

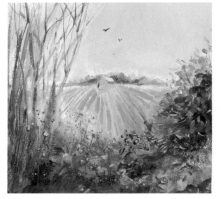

Landscape format Using a horizontal format enables more of the foreground to be included. Our eye lingers longer on the flowers and foliage before moving into the field.

Portrait format The vertical format emphasizes the vertical lines of the plowed field. So the eye quickly jumps beyond the foreground and into the field.

Square format Here, the eye is attracted to the distant house and solitary figure because they are almost encircled by the trees, bushes, and undergrowth.

USING THE RULE OF THIRDS

When planning your composition, try using the rule of thirds. Use a pencil to divide your support into thirds, both vertically and horizontally, to make a nine-box grid. Then put the important elements of your composition, such as interesting detail or areas of color contrast, on the four points where the lines intersect. Eventually, you won't need a pencil; you will have an instinctive feel for these points of emphasis.

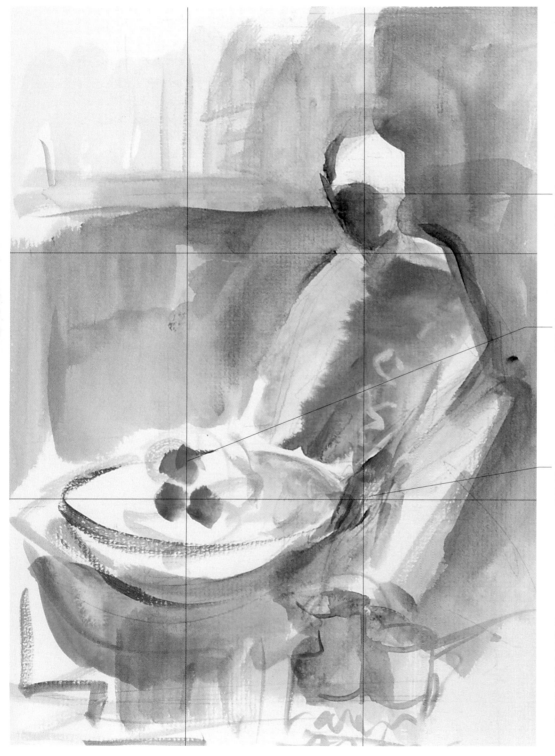

The face, the most important part of the figure, is placed near the top right intersection.

The colorful fruit are placed on the bottom left intersection.

The hand provides interesting detail and is placed on the bottom right intersection.

Market woman In this sketch, three of the four intersecting points are occupied by important elements. Note also how the woman is composed so she forms a dynamic diagonal from the top right corner down to the bottom left corner.

Sketching

Your sketchbook should be your constant companion. Think of it as a visual diary and a place to try out new techniques and new subject matter. No matter where you are, try to record scenes that give you a buzz. Often, you'll only have the chance to jot down a few lines, a simple reminder of a time and a place. If you aren't pressed for time, though, sit down and embark upon a more detailed study. Also sketch straight onto your support in pencil, so you have a guide when beginning your painting.

SKETCHES AND SKETCHBOOKS

Sketchbooks come in all shapes and sizes. Choose one that is small enough to carry around easily, with a sturdy cover to survive the wear and tear of traveling. If you intend to apply washes of color, make sure it has leaves of thick watercolor paper, not flimsy drawing paper.

Project sketch

A preliminary sketch for a painting need not be too detailed; an outline drawing is usually enough.

This preliminary sketch for the Boat on the beach project (*see pp.110–115*) was drawn directly onto the support before painting began.

Field sketch

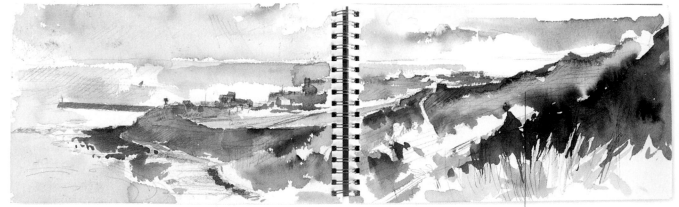

You can paint over the spine of your sketchbook to attain a dramatic panoramic format, ideal for coastal landscapes.

Color washes were added quickly, creating a wonderfully lively sketch.

USING SKETCHES

Sketches provide great reference material for paintings. And they have one big advantage over photographs: they force you to start making decisions about your final image. Which elements of the composition are you going to include? Which will you leave out? What colors will you emphasize? Photographs tell all, sketches force you to be selective.

Pencil sketch

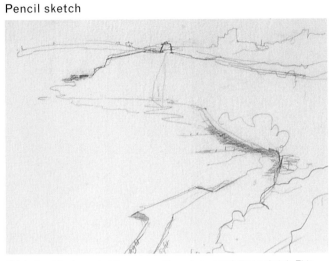

Think about the format of the composition when completing a sketch. This format is almost square and it keeps the eye within the bay.

Color sketch

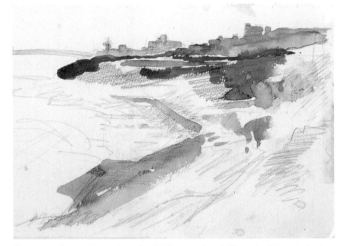

If you have time, add washes of paint to your sketch. They don't have to look finished, they are simply color "notes" you can refer to later.

Final painting

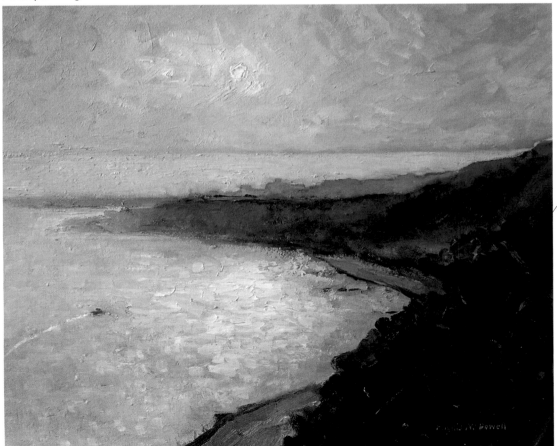

The foreground shadow tones are built up in blues, greens, and purples.

In the final painting, the artist included more sky to entice the eye to wander out to the horizon. Don't feel tied down to your sketches; they are a jumping-off point, not the finished work.

"Colors have a powerful effect on mood: use them to stimulate or soothe."

Choosing color

Color is a means of expression for the painter, and has a direct effect on emotions. In selecting a color scheme for your painting, you can choose whether to stimulate or to soothe. It is important to select colors and set the mood before you start to paint.

Limiting your palette will ensure a harmonious result, whereas trying to copy every color that you see before you is likely to result in discord. In fact, a painting can be worked successfully using just one pair of complementary colors.

COMPLEMENTARY COLORS

Once colors are applied to the painting, they react with each other and change according to where they are placed. Trying to incorporate too many colors into one work results in chaos. It is best to be selective and choose one pair of complementary opposites—blue and orange, red and green, or yellow and purple. Placed side by side, the colors will enhance each other. Mixing the two in varying proportions ensures an endless range of subtle and muted colors.

Blue and orange

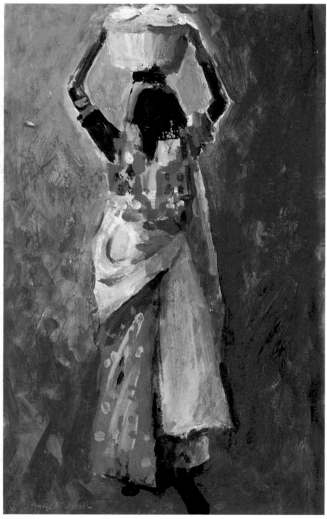

The vibrant blue background contrasts wonderfully with the complementary orange of the water carrier's sari.

Yellow and purple

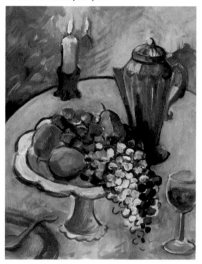

Yellow is a reflective color and creates areas of brightness in this painting, which uses only one pair of complementary colors to produce a striking still life.

Red and green

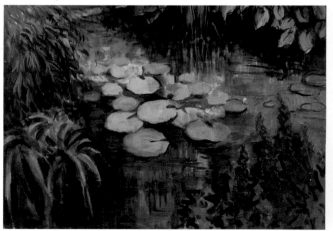

Red spikes of flowers in the foreground of this painting enhance the complementary greens of the lily pads.

ANALOGOUS COLORS

Colors that lie close together on the color wheel are called analogous; they slide gently, almost imperceptibly, around a small section of the color wheel, and are naturally harmonious. The colors yellow, orange, and red are examples of analogous colors. Even though these are stimulating in their own right, a touch of a pure blue-green placed on top of the glowing warmth will add an extra "zing." Cool green, blue, and blue-violet are other examples of analogous colors that create a feeling of peace and tranquillity.

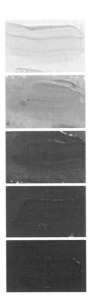

Yellows and reds These colors tend to blend together visually when used next to each other and create a harmonious effect that is, at the same time, warm and dominant.

Blues and greens These analogous colors form the basis of the painting below. Darker strokes are achieved by adding a thick impasto on top of a thin layer of paint.

Harmonious hues A limited palette of blues and greens creates a tranquil evening light. The figure dressed in blue harmonizes with the surrounding analogous colors and adds to the gentle mood of the painting.

A touch of a warmer color on the fence brings out the coolness of the other colors.

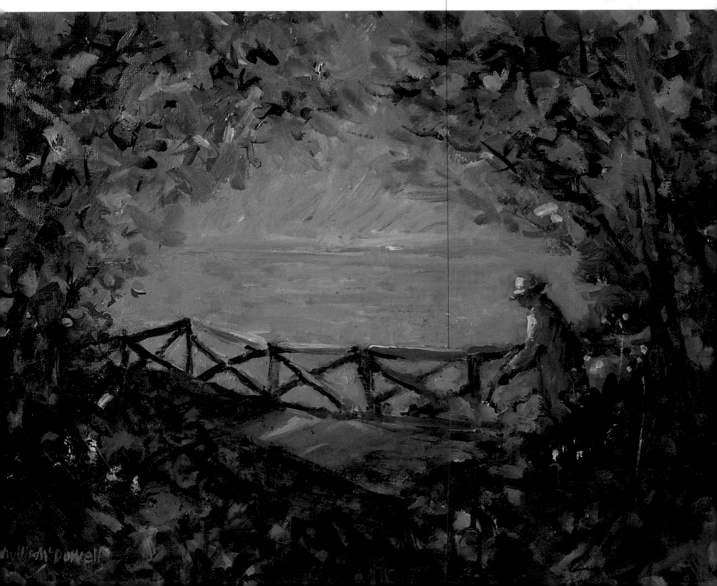

Gallery

Depending on how they are used together, color can create drama and impact or harmony and tranquillity, as this selection of paintings show.

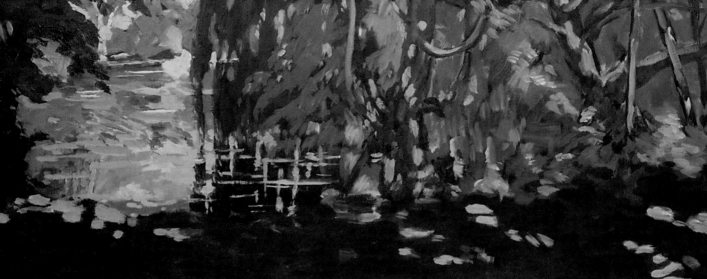

▲ Lakeside reflection

A variety of blues and greens cover the top third of this woodland painting. A spattering of soft pink sparkles against the cool greens and blues of the trees and sky, and against the rich, darker colors that form the foreground. *Wendy Clouse*

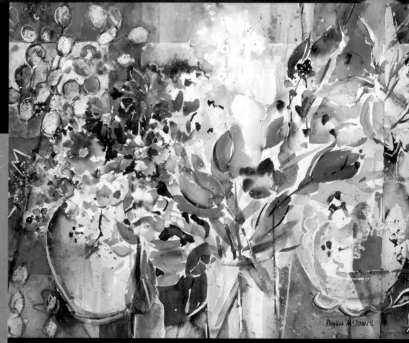

◄ Golden valley

Vibrant colors are used for dramatic effect in this uncluttered painting of a rural landscape. The warm, golden orange used for the fields in the foreground is intensified by the complementary violet shadow, which is cast diagonally across it. *Paul Powis*

▲ Honesty and tulips

The interplay of primary and secondary colors gives this painting vitality. Complementary red and green seem to vibrate, while the combination of violet and yellow, and blue and orange, produce a subtle foil for the strong primary colors. *Phyllis McDowell*

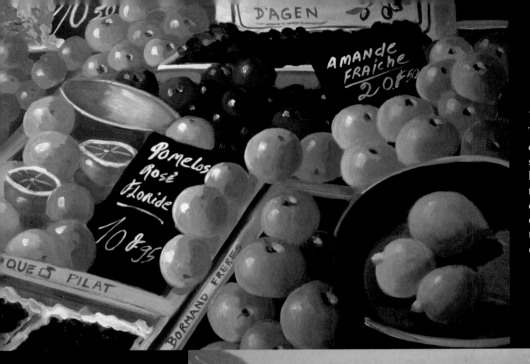

◄ Pomelos II

This arrangement of fruit displayed on a French market stall shows color at its most lucious. The soft green of the apples in the foreground enhances the warmth of the oranges, reds, and yellows that make up the rest of the composition. *Dory Coffee*

Lac St. Croix ►

The intense ultramarine blue band of color representing water is a restful foil for the orange rooftops, which stand out strongly against the blue backdrop. The same colors are used for the hills in the background but reduced in intensity to create the effect of distance. *Clive Metcalfe*

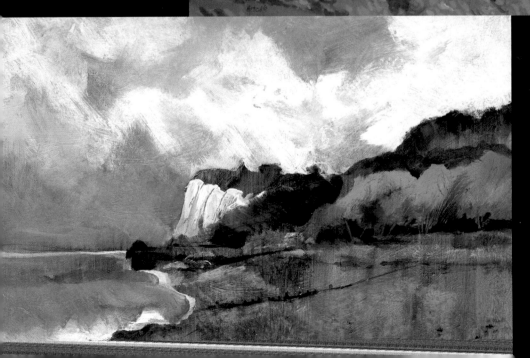

◄ Kingsdown II

An analogous color scheme has been selected for this painting. The blues and greens, which lie close to each other on the color wheel, create a cool mood, which is given greater intensity by the strategic placement of warm yellows. *Clive Metcalfe*

1 Flowers in a vase

In this painting, the color and vitality of flowers, rather than their botanical accuracy, is captured with a variety of brushstrokes. These brushstrokes are made with both a light and a heavy touch. Areas of bright orange and red are offset by the use of cool blues within the floral arrangement, and this complementary color scheme is echoed in the watery background colors. The contrasting geometric form of the vase is suggested with graded color. Glazes are used to add more depth to the flowers and to suggest shadows on the tabletop.

EQUIPMENT

- Watercolor paper—cold-pressed
- Brushes: No. 6 and No. 8 flat bristle, No. 8 and No.12 round, No. 1 rigger
- 2B Pencil
- Painting medium
- Indo orange, cadmium yellow deep, cadmium red deep, titanium white, light blue, phthalo blue, medium magenta

TECHNIQUES

- Glazing
- Spattering

SKETCH THE COMPOSITION

The pencil marks will not be seen in the finished painting.

Lightly sketch the outlines of your composition to position the vase and the shape of the flowers. There is no need to draw each individual flower in great detail at this stage.

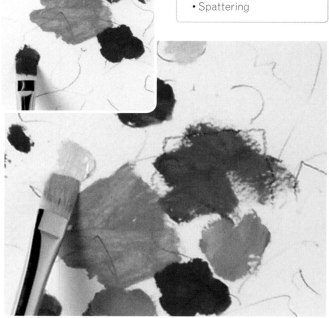

1 Paint the first flower with indo orange and painting medium and the next with cadmium yellow deep and painting medium, using the No. 6 flat bristle brush. Mix indo orange and cadmium red deep for smaller flowers, then add increasing amounts of titanium white for further flowers.

BUILDING THE IMAGE

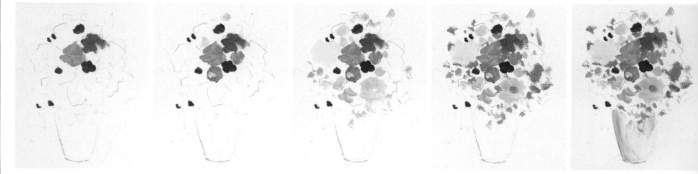

2 Mix titanium white with light blue to paint large flowers using the No. 8 flat bristle brush. Add phthalo blue to the mix to scumble smaller areas. Mix a violety pink mix from medium magenta and titanium white and use for small flowers, and for the center of the front blue flower.

GLAZING

When glazing, make sure your water does not contain any white paint, to ensure the glaze is transparent.

3 Glaze the vase with a mix of phthalo blue and painting medium. Wet the paper on the left side next to the flowers using a clean brush. Paint wet-in-wet with light blue—to give a soft edge to the color.

4 Paint wet-in-wet next to the vase with light blue. Continue to paint the background with colors drawn from those in the bouquet. Use the violety pink mix and then a mix of magenta and indo orange wet-in-wet.

5 Mix phthalo blue and light blue and use to fill gaps in the bouquet and suggest leaves and stems with the No. 12 round brush. Paint the center of the orange flower with light blue and the No. 8 round brush.

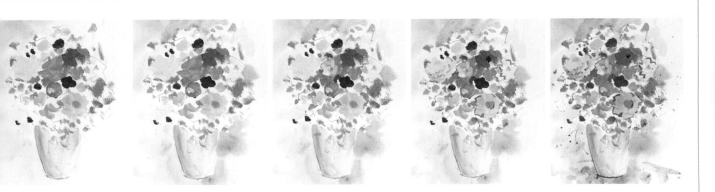

6 Add some form to the flowers by glazing over parts of them with a mix of light blue and titanium white with added painting medium. Use this mix too around the edge of some flowers to define them.

7 Use a gray mixed from the complementary colors—phthalo blue and indo orange—at the bottom of the vase. Add painting medium to the mix to paint the dappled shadow on the table.

8 Add dots with the mix of phthalo blue and light blue. Add stems using the gray mix and the No. 1 rigger brush. Outline areas of white with this mix to create small flowers. Add more fine stems using the light blue mix.

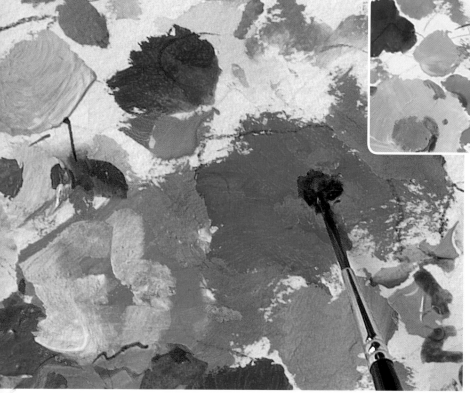

9 Paint the dark center of the bright orange flower with phthalo blue. Counterbalance this center by adding a few dark areas lower down in the bouquet with phthalo blue. Spatter phthalo blue with the No. 8 round brush.

Flowers in a vase ▶

This flower painting has an effervescent, joyful quality because it is executed quickly and spontaneously. Leaving some of the paper untouched allows the white paper to sparkle, in contrast with the bright colors.

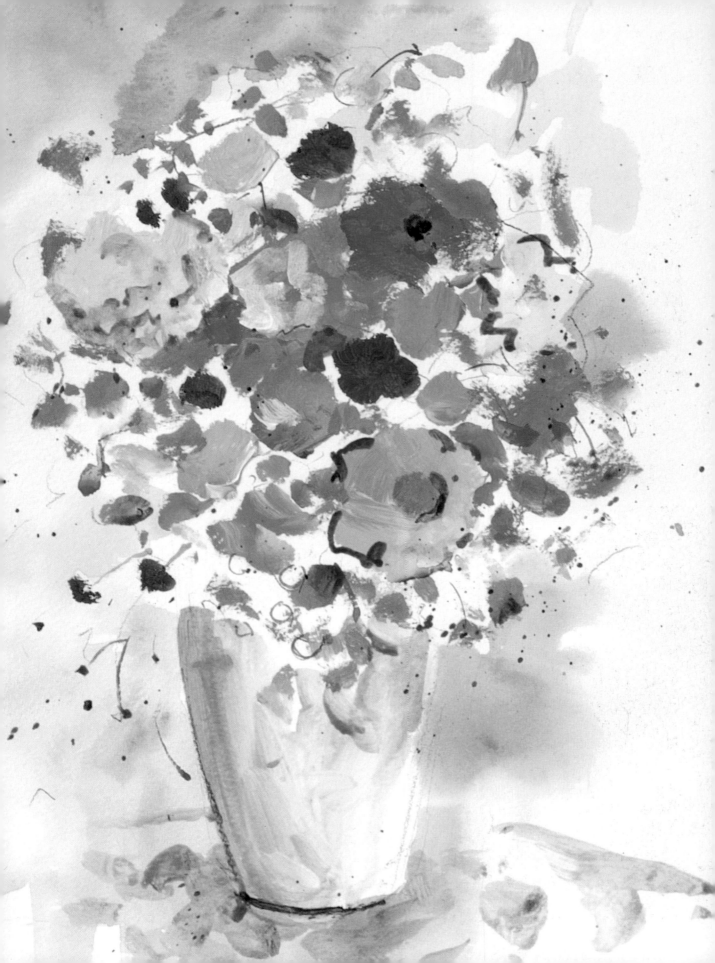

2 Rocky seascape

In this painting of sea and rocks, a range of analogous colors is used to create a harmonious, tranquil impression. Lightening the ultramarine blue used for the sky as it reaches the horizon, conveys a feeling of distance. Painting medium is blended with the blues and greens to create an underpainting for the sea. Once this underpainting is dry, the same cool colors and painting medium are applied as glazes to give an impression of the sea's watery depths. The dash of orange-red, depicting the flag on the boat, sings out and adds intensity to the analogous color scheme.

EQUIPMENT
- Watercolor paper—cold-pressed
- Brushes: No. 8 and No. 12 round, No. 1 rigger
- 2B pencil
- Painting medium
- French ultramarine, phthalo green, light blue, titanium white, cadmium red light, phthalo blue, yellow light hansa, indo orange

TECHNIQUES
- Wet-in-wet
- Glazing

The wet-in-wet technique is suitable for skies.

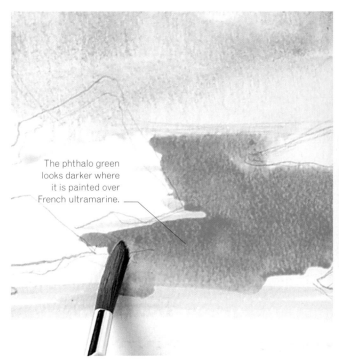

The phthalo green looks darker where it is painted over French ultramarine.

1 Sketch out your composition with a 2B pencil. Wet the sky with the clean, wet No. 12 round brush and paint, wet-in-wet, a wash of French ultramarine. Flick horizontal lines of French ultramarine over the dry paper of the sea.

2 Paint the sea with phthalo green using the No. 12 round brush. Mix the phthalo green with more water and paint the lower part of the sea so that the color is gradually graded from top to bottom.

BUILDING THE IMAGE

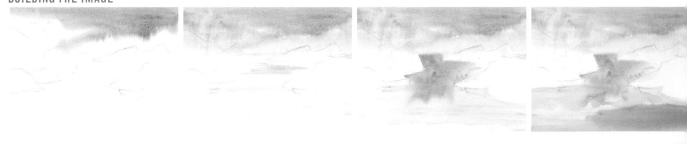

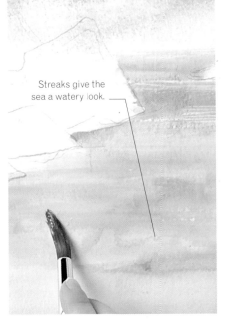

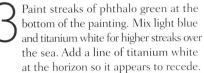

Streaks give the sea a watery look.

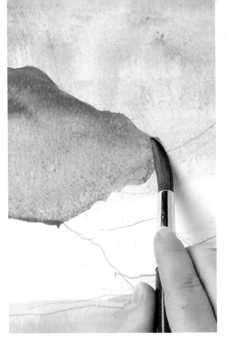

3 Paint streaks of phthalo green at the bottom of the painting. Mix light blue and titanium white for higher streaks over the sea. Add a line of titanium white at the horizon so it appears to recede.

4 Mix painting medium with phthalo green and titanium white and glaze this over the sea. Use less titanium white in the mix as you reach the bottom of the painting for a richer glaze.

5 Paint the distant hills with a mix of French ultramarine, cadmium red light, light blue, and titanium white. Add a little phthalo green to paint the hills on the left, which are closer.

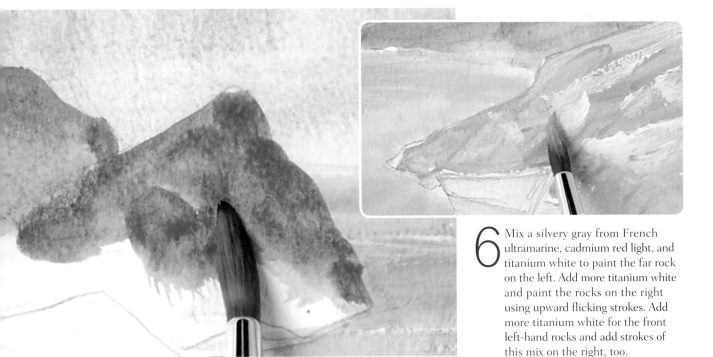

6 Mix a silvery gray from French ultramarine, cadmium red light, and titanium white to paint the far rock on the left. Add more titanium white and paint the rocks on the right using upward flicking strokes. Add more titanium white for the front left-hand rocks and add strokes of this mix on the right, too.

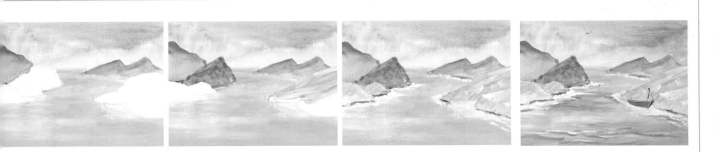

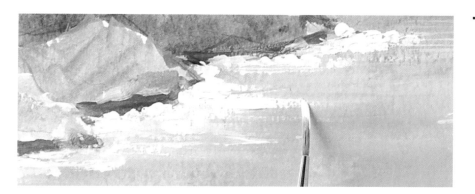

7 Paint a dark line of phthalo green at the base of the rocks. Paint thick dabs of titanium white for the breaking waves at their base. Darken the front left rock slightly with the silvery gray mix with added titanium white. Use the No. 1 rigger and titanium white to add more foam and highlights.

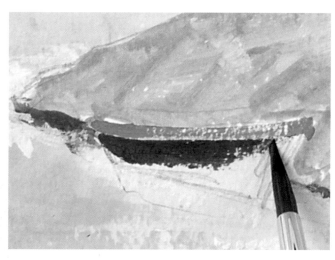

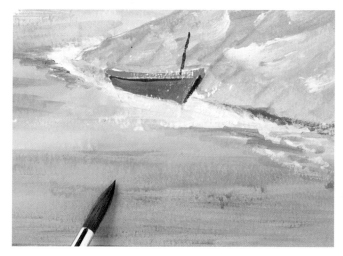

8 Paint the boat rim with phthalo blue and yellow light hansa. Paint the side with French ultramarine, adding titanium white for the lower part. Use French ultramarine and cadmium red light for the shadow on the far side of the boat and the mast.

9 Add some phthalo blue under the waves to define them. Glaze the sea with a mix of phthalo green and painting medium to add depth. Add a glaze of French ultramarine and painting medium at the bottom of the painting.

"Layering adds to the impression of depth."

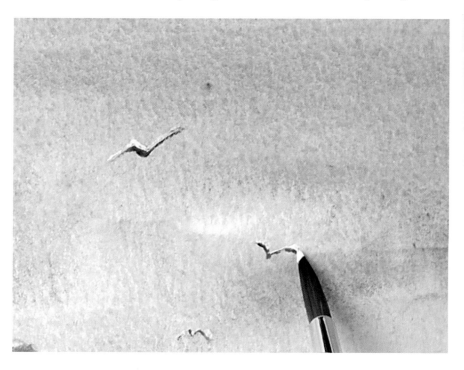

10 Add more French ultramarine to the right sky. Mix phthalo green, cadmium red light, and French ultramarine and, using the No. 8 round brush, paint three seagulls of varying size in the sky; the smaller seagulls appear to be farther away. Paint above these marks with titanium white.

11 Use the dark seagull mix to put in a line of rigging on the boat. Mix phthalo green and French ultramarine to paint lines of waves. Use titanium white for the crests. Add the flag on the boat's mast with indo orange.

▼ Rocky seascape

In this harmonious seascape, the use of analogous colors, wet-in-wet, and glazes combine to capture the depth of the water, while the foam at the base of the rocks implies its endless movement.

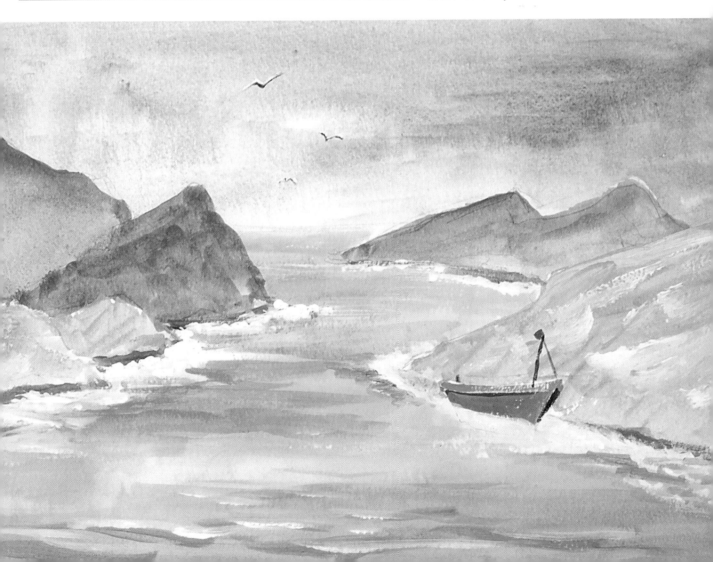

③ Garden arch

A garden of flowers is a visual delight that may be easier to paint if a manmade structure is incorporated into the composition. In this painting, the archway and rustic wall provide the framework for this balmy, tranquil scene. Analogous and complementary colors are used to depict the flowers that run riot against the passive, neutral-colored wall. The colors used in the background are lighter and less distinct, giving an impression of space. Sponging is used to good advantage for areas of foliage, while painting wet-in-wet creates a soft, muted feel.

EQUIPMENT
- Textured mountboard
- Brushes: No. 8 and No. 12 round, No. 2 and No. 10 flat bristle, No.1 rigger
- 2B pencil or charcoal stick
- Sponge
- Painting medium
- Yellow light hansa, titanium white, dioxazine purple, phthalo green, light blue, cadmium red light, phthalo blue, cadmium yellow deep, indo orange, cadmium red deep, medium magenta, French ultramarine

TECHNIQUES
- Sponging
- Wet-in-wet

ANALOGOUS COLORS

Analogous colors are naturally harmonious and can help to establish the mood of a painting. Here, warm yellows, oranges, and reds have been chosen to enhance the sparkle of the flowers.

1 Sketch your composition with pencil or a charcoal stick. Paint the sky with a mix of yellow light hansa and titanium white, using the No. 12 round brush. Add dioxazine purple to the mix and blend into the sky.

2 Mix phthalo green, dioxazine purple, and a touch of titanium white to suggest the foliage behind the wall using the No. 12 round brush. Use a sponge to dab and smudge on the same mix of phthalo green, dioxazine purple, and titanium white.

BUILDING THE IMAGE

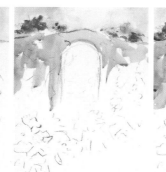
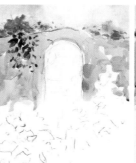
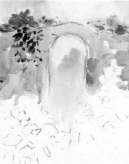

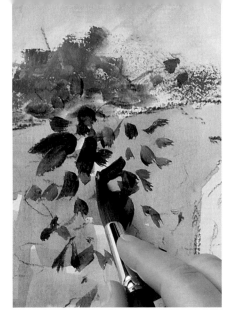

3 Paint the wall with a wash of light blue, dioxazine purple, and a little cadmium red light. Add phthalo green to the mix for foliage on the wall. Paint the dark leaves with a mix of phthalo green and phthalo blue. Add yellow light hansa for lighter ones.

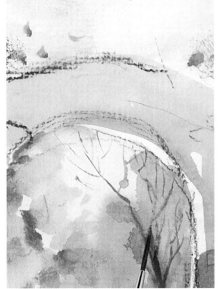

4 Paint the arch with yellow light hansa and dioxazine purple. Add foliage, wet-in-wet, with phthalo green and a phthalo green and dioxazine purple mix, and let this dry. Use the No. 1 rigger and the foliage mix with added light blue for the tree.

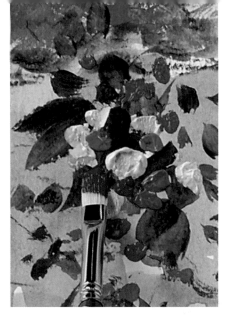

5 Paint the wall's shadow and stones with dioxazine purple and phthalo green. Add flowers with a cadmium yellow deep and titanium white mix, indo orange, a cadmium yellow deep and indo orange mix, cadmium red light, and cadmium red deep.

6 Paint the foreground with cadmium yellow deep. Add further color with a mix of light blue and titanium white. Paint thicker dabs of cadmium yellow deep and titanium white for flowers in the middle ground.

7 Use the No. 12 round brush to suggest flowers on the right with watery medium magenta. Mix phthalo green and light blue to suggest foliage. Mix medium magenta with titanium white to add dabs of opaque color for a sense of dimension.

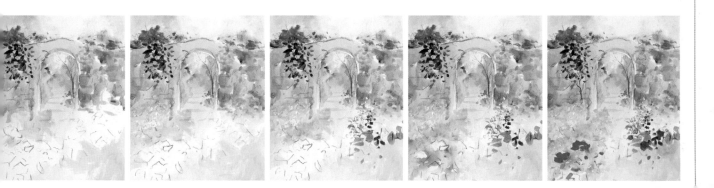

8 Paint leaves with a watery mix of phthalo green and yellow light hansa. Add cadmium red light to this mix for leaves on the right. Use French ultramarine and titanium white for flowers, add dots of titanium white, and let dry. Finish with dots of French ultramarine mixed with painting medium.

9 Wet the foreground on the left and paint flowers and leaves wet-in-wet with phthalo blue and phthalo green. Add more flowers with medium magenta, and a titanium white and light blue mix. Move to the right to paint flowers with cadmium red deep and cadmium red light.

10 Suggest leaves and stems with phthalo green and light blue using the No. 1 rigger. Add cadmium red deep for detail lower down the wall. Put shadow behind the left-hand yellow flowers with dioxazine purple and phthalo green. Soften the edge of the yellow flowers on the left with a mix of light blue and titanium white. Add watery phthalo green over the top of the yellow flowers on the right.

Garden arch ▶

This painting of vibrant summer flowers, basking against a neutral wall under a golden sky, is organized to lead the eye through the archway, and into an area where the imagination can come into play.

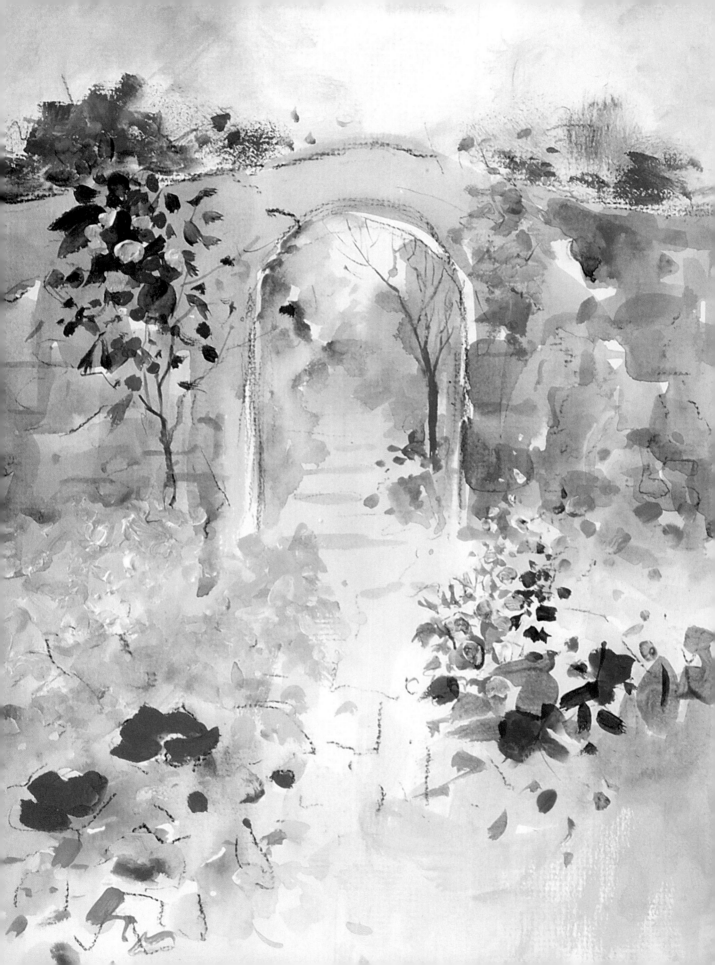

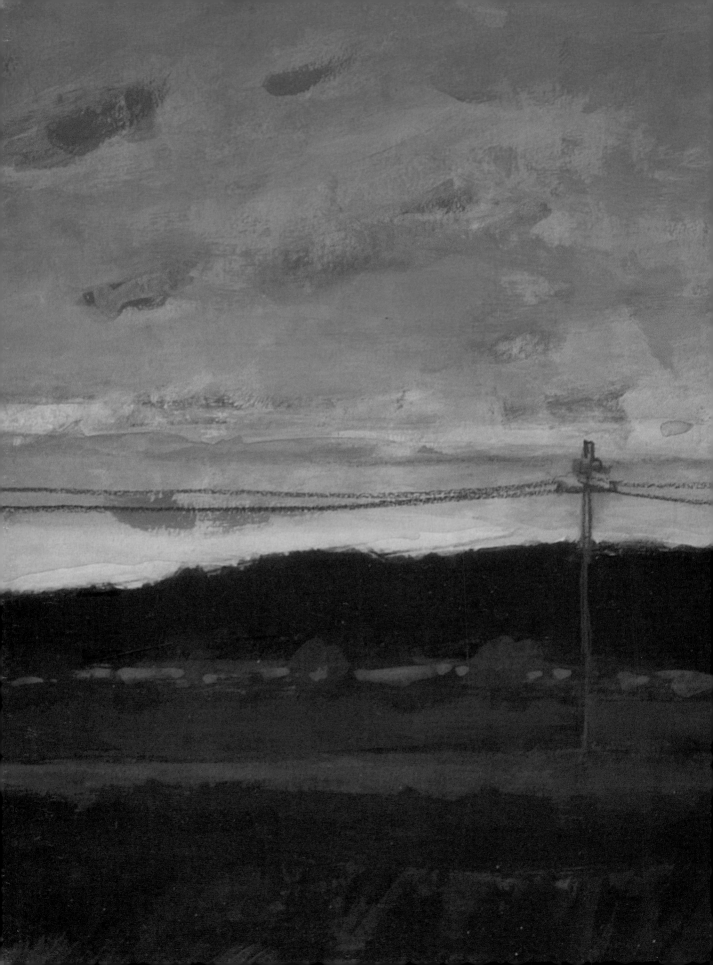

Light

"Plan your lighting:
use it to give shape,
color, and form."

Working with light

The way you use light will have a major impact on your painting. The direction of light—whether the source is from behind, in front of, or from the side of the subject—alters the appearance of colors, detail, and texture. Lighting can also influence mood. Light is easier to control if it is artificial—from a lamp or candle, for example. Natural light is constantly changing, in both its quality and direction. So, if you are using natural light, try to work within a time limit to minimize the effects of changing light conditions.

DIRECTIONAL LIGHT

The appearance of a subject changes completely when lit from different directions, whether under natural or artificial light. Backlighting creates dramatic, clearly defined shapes, and eliminates most surface detail. When lit from the front, the image becomes clear and bright: color, decorative patterns, and texture are fully revealed. Sidelighting exposes the three-dimensional aspect of a subject. Although color, pattern, and texture can be seen, they don't dominate. Instead, the interplay of light and dark is the most important aspect of the painting.

Backlighting

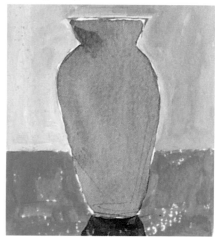

Backlighting highlights the silhouette of the vase and the vertically cast shadow.

Frontlighting

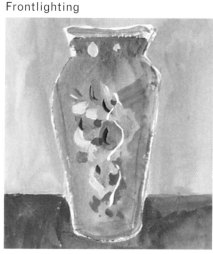

Frontlighting reveals the decoration and shape of the vase.

Sidelighting

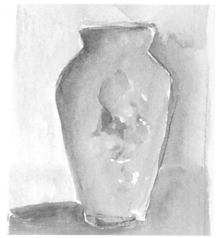

Sidelighting shows the three-dimensional form of the vase.

ARTIFICIAL LIGHTING

When painting indoors, you can control the lighting on the subject by setting up an artificial light. An adjustable desk lamp allows you to choose the direction you want the light to come from. Changing the position of the lamp will completely change the appearance of the subject, for example casting a shadow or highlighting different areas.

Still life lit from above In this set-up, the light from the adjustable lamp is directed onto the flowers, highlighting their riotous color. The side of the bottle receives diffuse light. Areas that are not getting direct light are plunged into shadow.

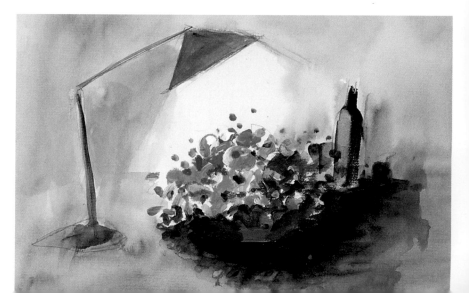

LIGHT IN NATURE

The sun changes a landscape from the time it rises until the time it sets. Evening light is very different to the light of the morning and alters the whole emphasis, pattern, and composition of a painting. Patterns of light and dark, color, and the relationships between colors, change throughout a day, as well as from from day to day and season to season. Be conscious of light when looking at a landscape and use your observations to help capture nature's magical moments.

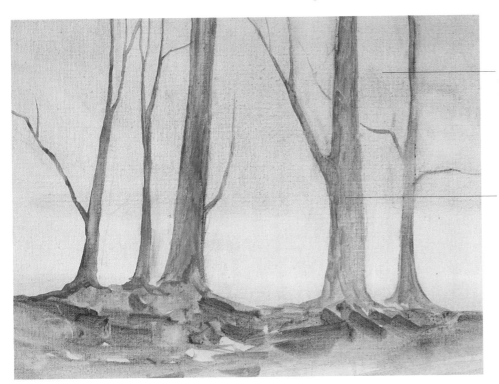

Early morning light creates soft, muted colors.

Detail on the tree trunk is only just visible.

Trees at dawn The early morning light shows the soft, natural color of the tree trunks and the ground. The texture of the surfaces is just visible. As the sun rises, the colors will intensify and more detail will be revealed as the frontlighting gradually becomes brighter.

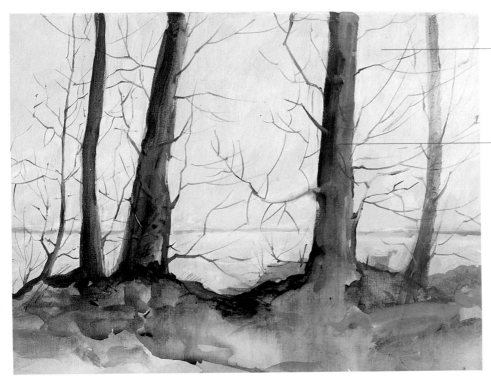

Evening light creates a luminous gold color in the sky.

Backlighting makes the detail on the tree trunks disappear, and the shapes become silhouetted against the sky.

Trees at dusk The sun is setting behind the trees, leaving the sky a luminous gold color. The backlighting throws the trees and foreground into cool violet-green silhouettes, eliminating the natural color of foliage and trunks. The intricate tracery of the fine branches and twigs is clearly defined against the pale sky.

Gallery

The direction of light, from the front, back, or side of the subject, is all-important to the drama and pattern of a painting.

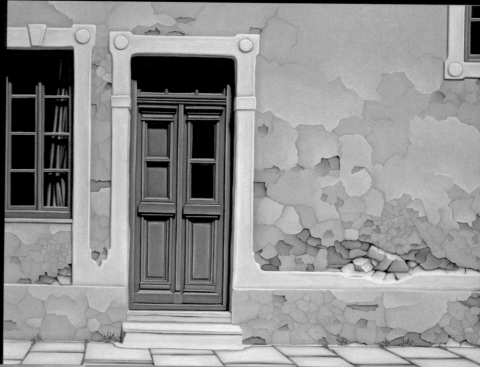

Blue wall and red door ▶

The strong front lighting in this composition picks out every detail of the door, windows, and curtain. The pattern on the sidewalk is clearly defined, as is the texture on the walls. The lighting gives a theatrical impression. *Nick Harris*

▼ Bluebells and yellow flowers

Direct, front lighting illuminates the natural color of the flowers and leaves. The patterning on the vase and background add to the riot of color. Impasto paint makes the color more forceful. *Sophia Elliot*

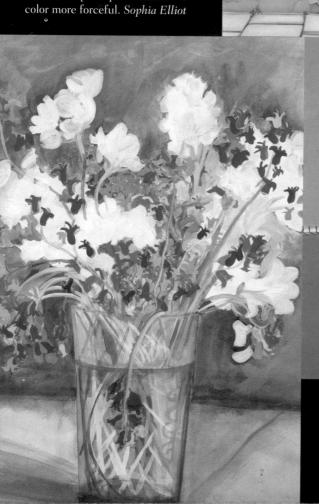

▲ On the road to Chestertown

Sidelighting dramatically picks out the hard edges of the main forms in this painting—the dog and the man's legs—and creates distinct patterns of medium and dark tones. The contour of the dog's ears is seen clearly against the flat blue sky. *Marjorie Weiss*

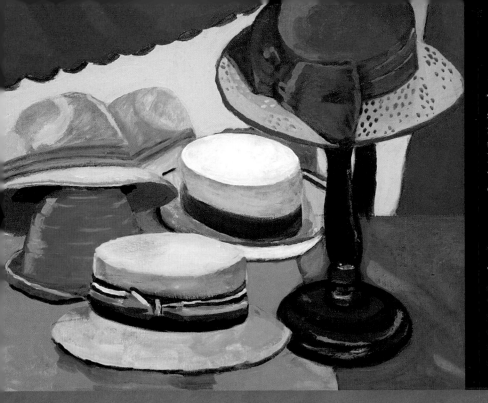

◀ Hats

The still life arrangement of hats in a store is lit by artificial light, which focuses on the color and texture of the fabrics. The weave of the straw hat can be picked out and contrasted with the shiny red ribbon that decorates it. *Rosemary Hopper*

▼ Winchelsea sunset

The backlighting created by the setting sun gives a dramatic appeal to this painting. The near distance is silhouetted using mixes of rich, dark color. The pinkish orange strip of sky on the horizon glows between strips of cool blues. *Christopher Bone*

4 Pears on a windowsill

Backlighting creates silhouettes, as in this dramatic hard-edge painting of three pears sitting provocatively on a windowsill, set against a sky of blended blues and violet. The fruit is drawn precisely, and the stems are used as a device to direct the eye across the composition. The positioning of the pears, and the spaces in between, are important for balance in the painting. The light on a narrow sliver of the windowsill creates a contrast with the rich black of the pears and lower windowsill, which is achieved by glazing with layers of luminous, transparent dark colors.

EQUIPMENT
- Canvas board
- Brushes: No. 8 and No. 12 round, No. 12 filbert, No. 2 flat bristle, No. 1 rigger
- Masking tape, painting medium, stick of chalk
- Phthalo blue, medium magenta, titanium white, light blue, cadmium yellow deep, cadmium red deep, phthalo green, yellow light hansa

TECHNIQUES
- Blending
- Hard edge
- Mixing blacks

1 Cover the window frame with masking tape. Paint the sky with a mix of phthalo blue, medium magenta, and titanium white. Add more titanium white and overlap with strokes of this mix. Continue down the painting with overlapping strokes using a mix of light blue and increasing amounts of titanium white.

2 Add cadmium yellow deep to the mix to make a light green and paint this below the blue, blending for a gradual change between the colors. Blend below the green with added titanium white. Add medium magenta to make a warm gray for the bottom of the sky.

BUILDING THE IMAGE

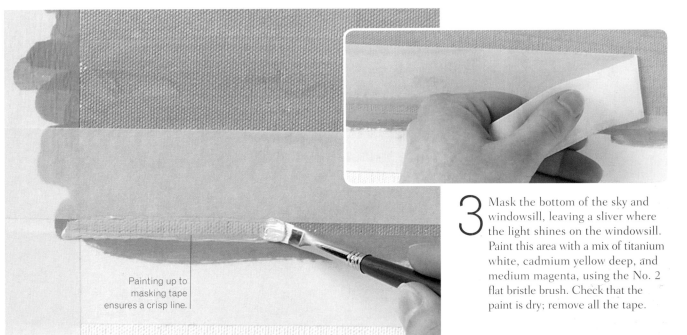

Painting up to masking tape ensures a crisp line.

3 Mask the bottom of the sky and windowsill, leaving a sliver where the light shines on the windowsill. Paint this area with a mix of titanium white, cadmium yellow deep, and medium magenta, using the No. 2 flat bristle brush. Check that the paint is dry; remove all the tape.

4 Cover the pink stripe with tape. Glaze cadmium red deep and painting medium over the exposed windowsill. Layer glazes of phthalo blue and painting medium and then phthalo green and painting medium over the top. Let dry before removing the tape.

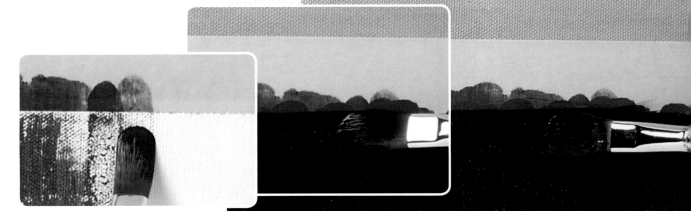

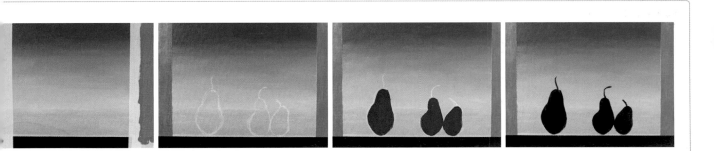

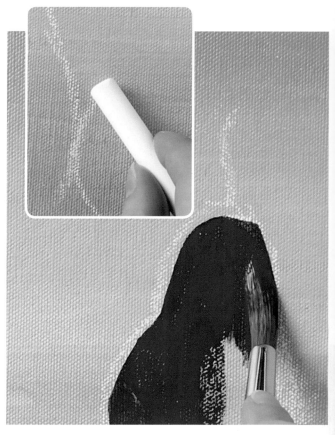

6 Draw in the outline of the three pears using a stick of chalk. Paint the pears with cadmium red deep using the No. 12 round brush. Bring the color over the windowsill so the pears appear to be sitting on it. Load the brush with paint in order to paint the pears in as few strokes as possible.

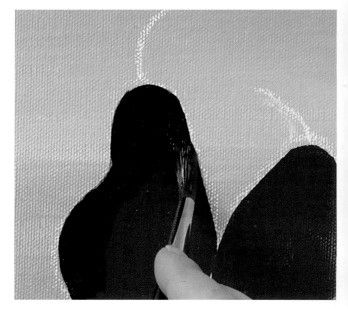

5 Put masking tape along the edges of the window frame. Paint the window frame medium magenta with the No. 12 filbert brush. Mix yellow light hansa with painting medium and glaze this mix over the medium magenta.

7 Mix phthalo green and painting medium and glaze over each of the pears. Switch to the No. 8 round brush to paint the edges of the pears with this glaze. Paint just below each pear with the green mix for the reflected color on the windowsill.

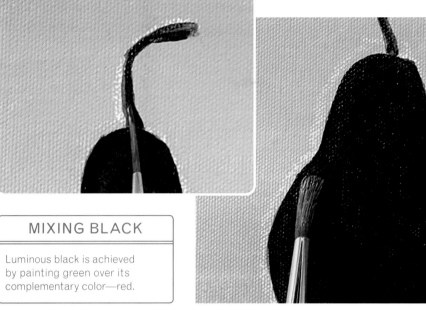

8 Mix cadmium red deep and phthalo green and paint the stalks of the pears using the No. 1 rigger. Glaze a mix of phthalo green and yellow light hansa for subtle highlights on the pears, using the No. 8 round brush. Remove the chalk with a clean, damp brush.

MIXING BLACK

Luminous black is achieved by painting green over its complementary color—red.

▼ Pears on a windowsill

The well-planned use of masking tape has helped to create the contrast between hard edges and soft blending, which in combination with the contrast of dark and light, makes this a striking painting.

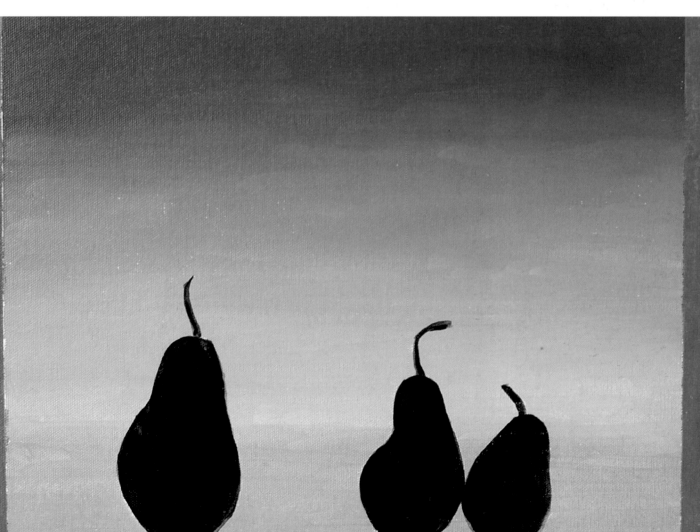

5 Cat among flowers

This cat with its inscrutable expression, sitting sedately among flowers, is painted on brown throwaway cardboard—one of many different unconventional art surfaces to experiment with. In this painting, there is no obvious shadow because the light is coming from the front. The cat is illuminated, showing details of eyes, nose, mouth, and whiskers, which are drawn in graphically. Dry brushwork and scumbling convey the texture of the cat's fur. Areas of the cardboard are left unpainted, and the addition of spontaneous drawing lines gives the painting movement and life.

EQUIPMENT

- Cardboard
- Brushes: No. 6 and No. 10 flat bristle, No. 8 and No. 12 round, No. 1 rigger
- Painting medium
- Cadmium red light, light blue, phthalo blue, cadmium red deep, medium magenta, titanium white, French ultramarine, phthalo green, cadmium yellow deep

TECHNIQUES

- Drybrush
- Using a rigger
- Scumbling

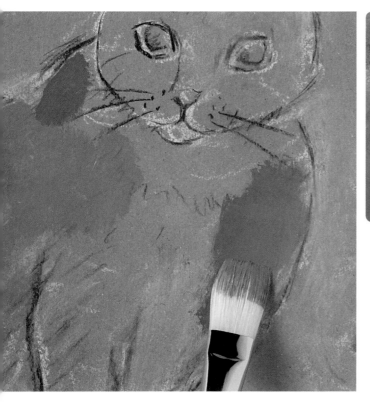

1 Sketch your composition with white chalk and charcoal. Paint the cat with the No. 10 flat bristle brush and a light gray mix of cadmium red light and light blue. Scrub on the paint to lay down the major areas of color.

2 Mix phthalo blue, cadmium red light, and cadmium red deep for a darker gray, and paint the outline of the cat using the No. 8 round brush. Add more cadmium red deep to the mix to drybrush a suggestion of markings on the cat's fur.

BUILDING THE IMAGE

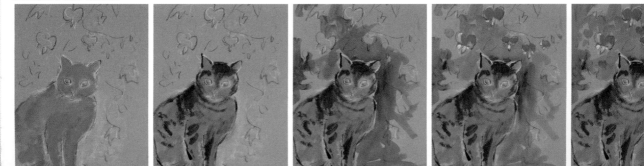

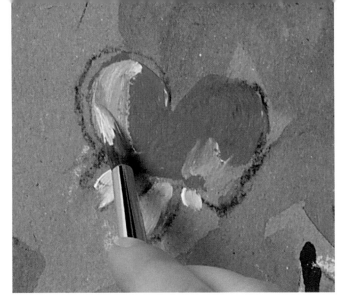

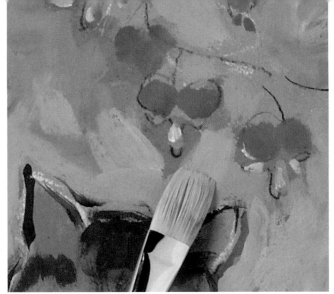

3 Use a watery mix of phthalo blue and cadmium red light for part of the background. Paint flowers with medium magenta; while wet add titanium white for a paler pink. Mix medium magenta and titanium white for smaller flowers. Add cadmium red light to this for variety.

4 Paint the sky with a mix of phthalo blue, cadmium red light, and titanium white using the No.10 flat bristle brush. Add French ultramarine and a little titanium white for variety. Continue to add more of both of these mixes to brighten areas of the sky.

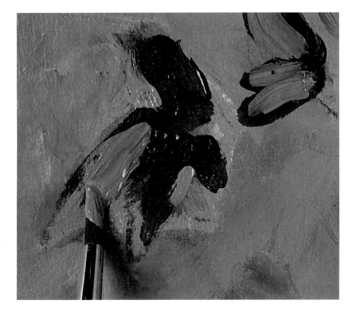

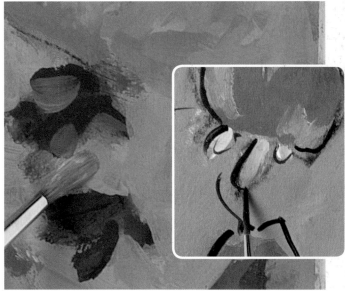

5 Paint the leaves with phthalo green. Modify the green by adding cadmium red light and phthalo green to paint parts of the leaves. For further variety, add cadmium yellow deep and add titanium white to this for areas of reflected light.

6 Mix French ultramarine and titanium white to paint the background and define the leaf shapes. Outline flowers and leaves with phthalo blue, cadmium red light, and cadmium red deep. Leave spaces in the outlines to suggest movement.

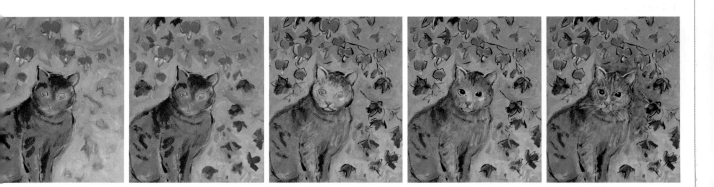

7 Add lines of titanium white to the leaves using the No. 1 rigger. Add a touch of medium magenta to the titanium white for more lines.

8 Mix titanium white and painting medium to glaze the cat's head and scumble over its body. Add warmth to the head with glazes of medium magenta and light blue, and cadmium red light and cadmium yellow deep. Paint the cat's nose with medium magenta and titanium white.

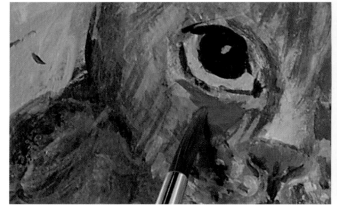

9 Mix cadmium yellow deep, phthalo green, and titanium white to paint the cat's irises. Paint its pupils with a mix of phthalo blue and cadmium red light and outline its eyes with this mix using the No. 1 rigger.

10 Warm the head with medium magenta, cadmium red light, and titanium white using the No. 12 round brush. Paint a glaze of phthalo blue and a little cadmium red light to darken the background.

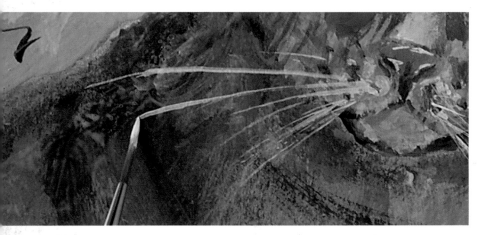

11 Paint each whisker with one fast stroke using the No. 1 rigger and titanium white. Mix French ultramarine with a little titanium white to paint parts of the sky.

Cat among flowers ▶

The simple blue sky background, the areas of unpainted cardboard, and the rough, dry brushstrokes of the cat's fur, contrast with the cat's whiskers and the lively brushwork of the flowers and leaves, which have been painted with the rigger brush.

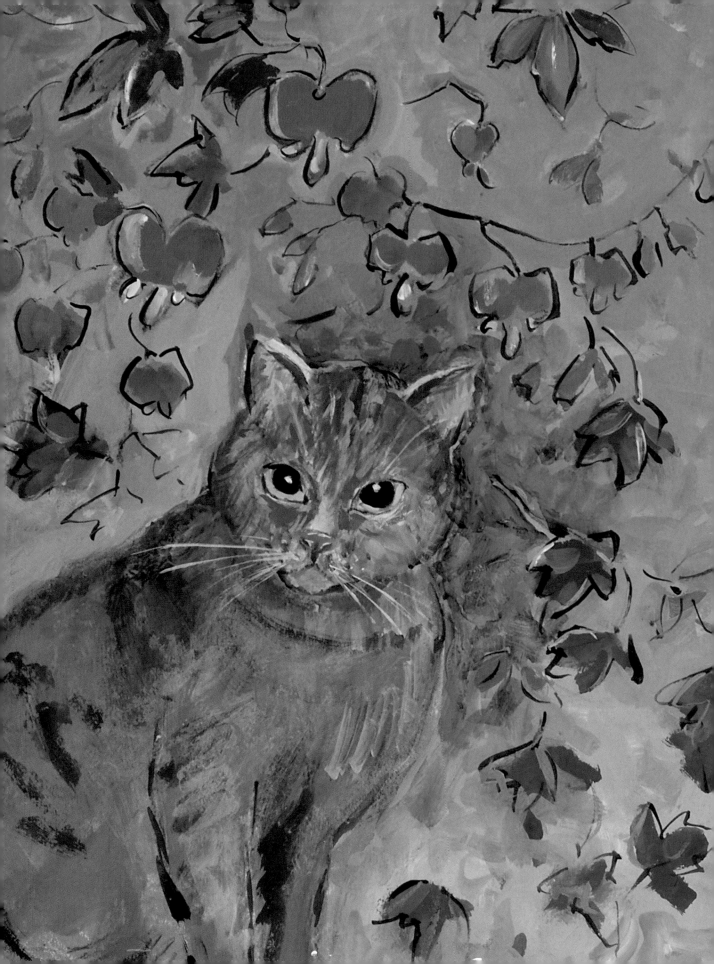

6 Sunlit interior

In this painting of an interior, the main light source, coming from the window, illuminates the transparent glass objects on the windowsill, throws the opaque ornaments in the room into silhouette, and floods light onto the polished tabletop. By applying thick layers of paint, a technique known as impasto, the brushstrokes stand up in relief. Acrylic paint dries fast, so here glazes are painted on top of the impasto almost immediately. Painting thick with texture paste, before applying glazes, effectively creates the gilding on the mirror and the handles on the cabinet.

EQUIPMENT
- Canvas board
- Brushes: No. 8 and No. 12 round, No. 2 and No. 8 flat bristle, No. 1 rigger
- Texture paste, painting medium
- Indo orange, phthalo blue, titanium white, French ultramarine, cadmium yellow deep, cadmium red light, cadmium red deep, medium magenta, yellow light hansa

TECHNIQUES
- Shadow colors
- Glazing

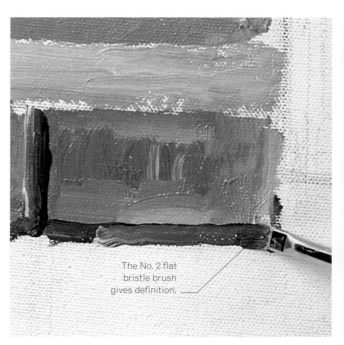

The No. 2 flat bristle brush gives definition.

1 Use indo orange, phthalo blue, titanium white, and texture paste to make a gray mix. Paint the wall, around the mirror, with this thick mix, using the No. 8 flat bristle brush. Add more titanium white to the mix to paint the wall on the far left of the painting.

2 Add more indo orange to the gray mix for the top of the cabinet, and more phthalo blue and titanium white for its front. Outline the cabinet drawers with a mix of phthalo blue and indo orange and fill in the rest of the cabinet with mixes of indo orange, phthalo blue, and titanium white.

BUILDING THE IMAGE

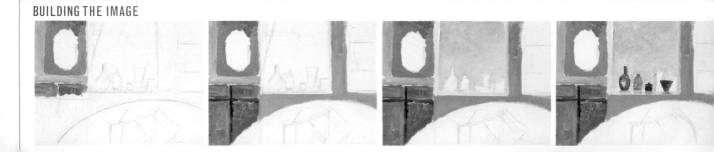

3 Paint the wall in shadow under the window and to its right with the gray mix with added titanium white. Mix French ultramarine and titanium white to paint the sky, using the No. 12 round brush. Blend a mix of indo orange and titanium white into the blue for lightness.

"The source of light dictates the feel and mood of a painting."

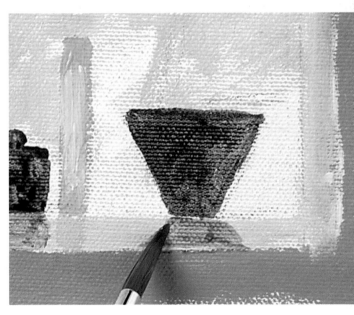

4 Paint the window frame titanium white with a little cadmium yellow deep. Paint the left bottle cadmium red light, and the light shining through titanium white. Mix these two bottle colors to paint its reflection. Paint the second bottle and its reflection with French ultramarine and painting medium.

5 Paint the third bottle phthalo blue and cadmium red light, add painting medium for its reflection. Paint the fourth cadmium yellow deep, and use titanium white for the light shining through. Paint the fifth bottle phthalo blue and cadmium red light; add painting medium for its shadow.

6 Paint the top left book cadmium red deep, the box cadmium red deep and titanium white, and the shelves with gray mix. Suggest books with stripes of cadmium yellow deep, French ultramarine, phthalo blue with titanium white, and cadmium red deep mixed with French ultramarine.

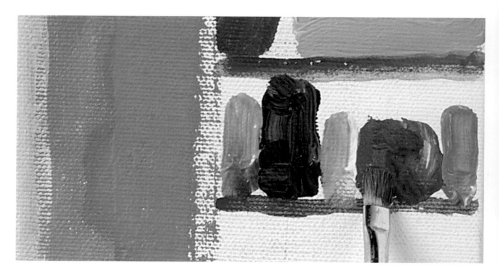

7 Paint the first file with phthalo blue and titanium white, the second with cadmium yellow deep, and a mix of these for the other three files. Paint magazines on the bottom shelf with a green mix of phthalo blue and cadmium yellow deep, and with cadmium red light.

8 Mix medium magenta and texture paste for the lampshade. Add titanium white where it catches the light. Mix phthalo blue and medium magenta for the stand; add its reflection with titanium white.

9 Paint the reflection on the table with a mix of medium magenta, cadmium yellow deep, and titanium white. Paint the rest of the table with cadmium red deep, phthalo blue, medium magenta, cadmium yellow deep, and titanium white.

10 Paint the dark reflections in the mirror with a mix of phthalo blue and painting medium and add titanium white for the light reflections. Add cadmium red deep to both mixes for variety. Use a brush handle to scratch out some of the paint to suggest reflections.

11 Paint the shadow on the wall using a mix of phthalo blue and cadmium red light. Mix phthalo blue and cadmium red deep to suggest shadows on the frame. Paint the gold frame with cadmium yellow deep, yellow light hansa, and texture paste, using the No. 8 round brush.

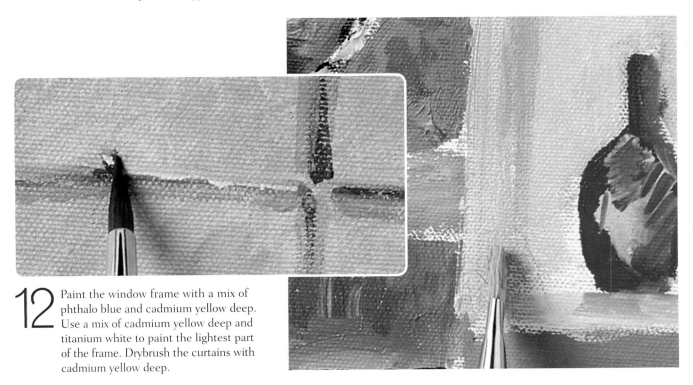

12 Paint the window frame with a mix of phthalo blue and cadmium yellow deep. Use a mix of cadmium yellow deep and titanium white to paint the lightest part of the frame. Drybrush the curtains with cadmium yellow deep.

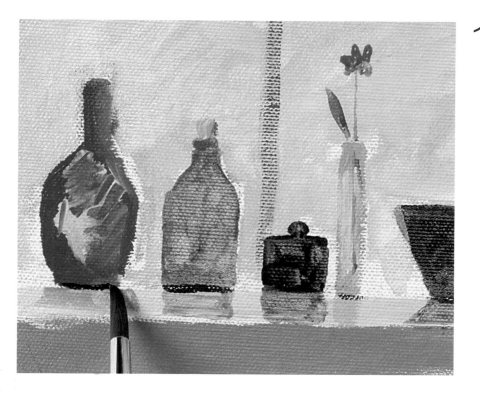

13 Mix phthalo blue and yellow light hansa for the flower's stem. Paint the petals with indo orange. Use phthalo blue and cadmium red light to paint a dark line at the base of each of the bottles. Add touches of the green mix to the red bottle and add the top to the blue bottle with a mix of indo orange and cadmium yellow deep.

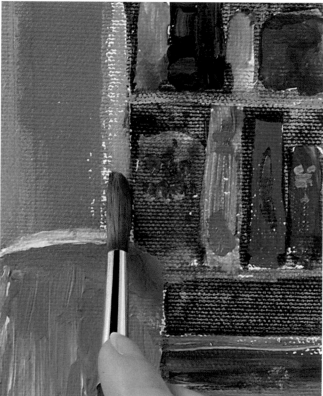

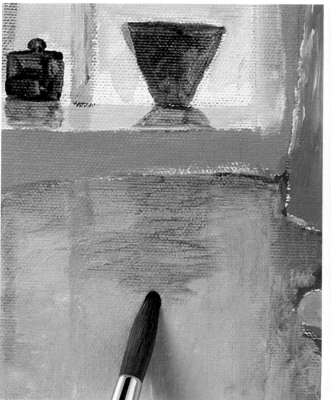

14 Use phthalo blue, cadmium red light, and painting medium for the back of the bookcase. Add lettering to the books with complementary colors—indo orange, the green mix, and medium magenta. Paint the vertical edge with French ultramarine and titanium white.

15 Glaze the shadow behind the curtain with phthalo blue, cadmium red deep, and painting medium. Glaze the table with yellow light hansa and painting medium. Glaze phthalo blue, cadmium red deep, and painting medium for the shadows on the table.

16 Paint the cabinet's handles with phthalo blue, a touch of indo orange, and texture paste. Add brightness to them with a mix of cadmium yellow deep, yellow light hansa, and texture paste. Glaze the cabinet and shadows on the left of the table with cadmium red deep and painting medium. Blend in the glaze for a subtle transition between dark and light.

▼ Sunlit interior

The drama that light can give to a painting is shown here as sunlight floods through the window, illuminating the central third of the composition in contrast with the darker areas to the left and right. Layers of glazes effectively create the polished surface of the table and the colorful shadows and areas of reflected light.

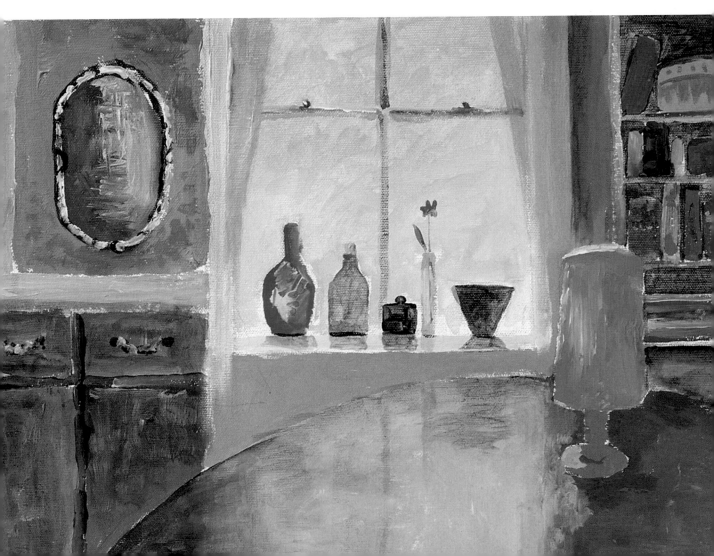

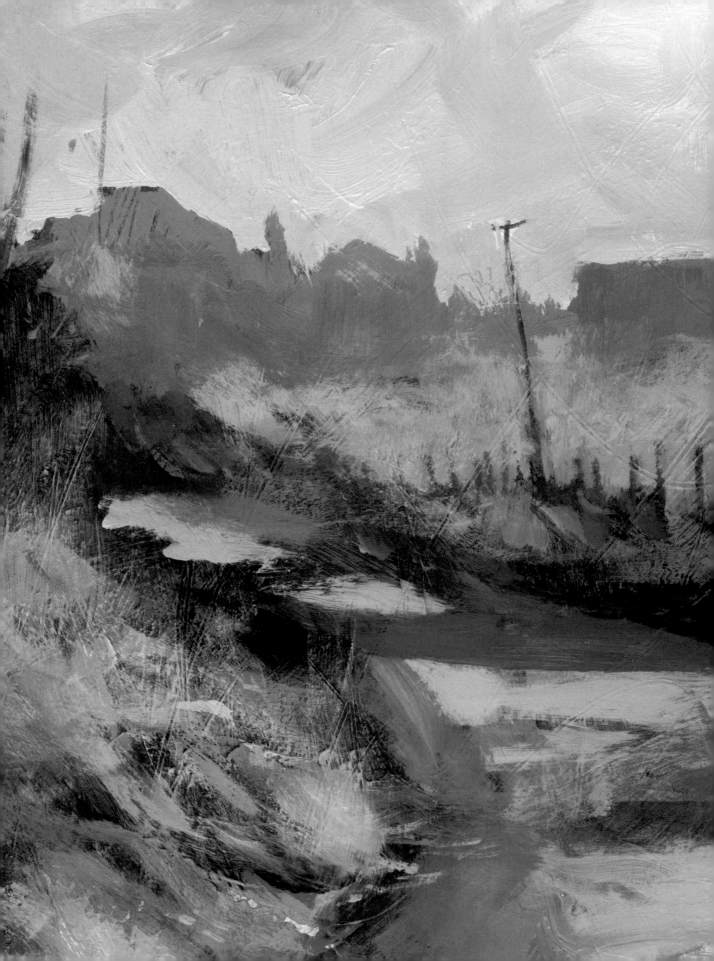

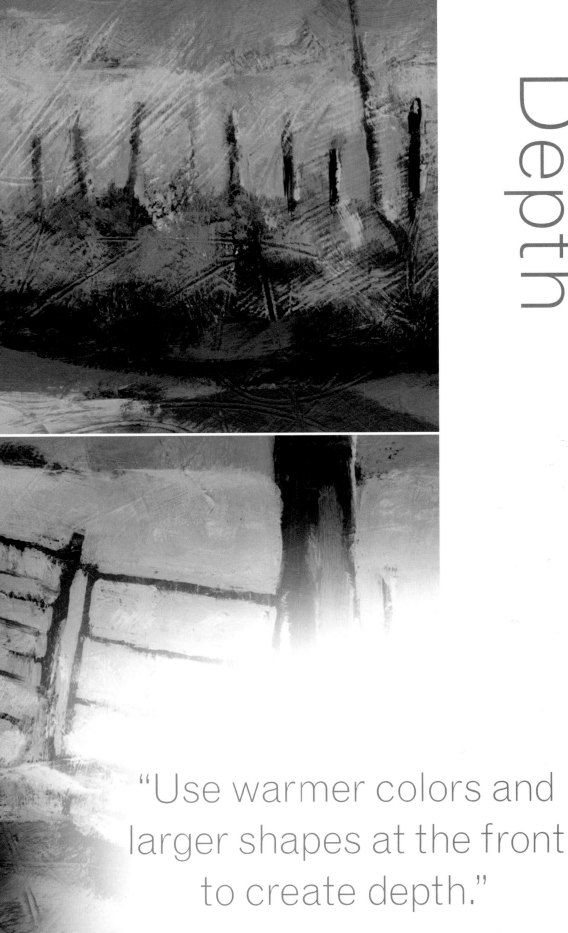

Depth

"Use warmer colors and larger shapes at the front to create depth."

Creating depth

Giving the impression of depth in your painting is a way of inviting the viewer into the picture. There are three ways of creating depth: color, scale, and linear perspective. Strong, warm colors such as red and orange make a subject come to the front, whereas cool, pale colors such as blue appear to recede. An object that is in the foreground will also appear much larger than a similar sized object in the distance. Knowledge of the rules of perspective will also help you create a sense of depth in your paintings.

WARM AND COOL COLORS

Color can be used to create a sense of depth in your painting. The red, green, and blue bands of color here illustrate color recession. Warm colors, like red and orange, are dominant and appear to come forward. Blue appears to recede, so it is used to give the impression of distance. Green, neither truly warm nor cool, slots in behind the red and in front of the blue.

Cool blue appears to recede.

Red is a hot, dominant color and appears to come to the front.

COLOR PERSPECTIVE

The colors of objects appear to change depending on their distance from you. This is because atmospheric conditions affect how we see color. Colors close to you appear strong and warm. Distant colors look less bright, less defined, and take on a cooler bluish hue. You can use this knowledge of color perspective to create depth in your paintings.

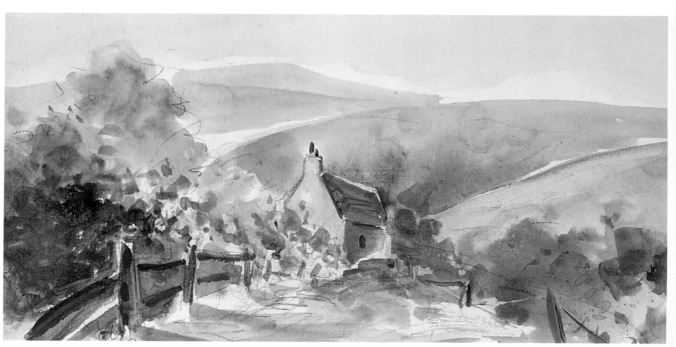

Color and depth The use of warm and cool colors in this rural scene creates an impression of depth. The fence and foliage are painted in warm colors, which come forward and establish the near distance. Faraway hills appear to be soft blue and violet-gray in color.

SCALE AND LINEAR PERSPECTIVE

A sense of depth can be achieved by using scale and linear perspective. Objects get smaller as they recede into the distance—this is scale. In a sketch of a row of houses, for example, those in the foreground will be larger than those farther away. The rules of perspective are also helpful in creating depth in your painting. Lines that are parallel in reality appear to converge and meet on the horizon. This convergence occurs at the vanishing point, which can be seen clearly here in the composition of the street scene.

Preliminary sketch

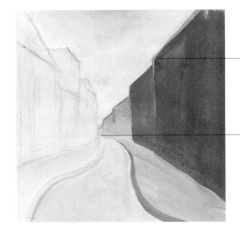

Rooftops slope downward into the distance.

The lines of the street converge at the vanishing point.

Finished painting

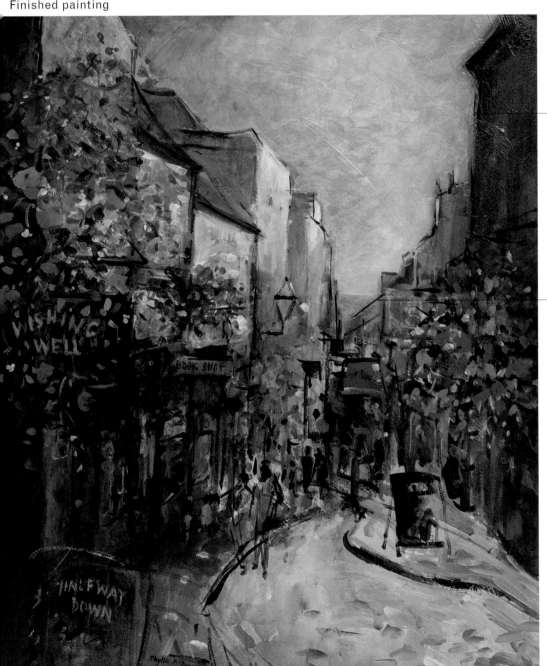

Strong, warm colors and large scale bring the side of this building to the foreground.

The buildings appear to converge as they recede into the distance. Cool colors add to the sense of depth.

Scale and linear perspective Parallel lines appear to converge in this painting, and the buildings on the street appear to get smaller as they recede. The flower baskets, people, and shop signs become smaller and less distinct as they go deeper into the painting.

A combination of methods, including the correct use of color, scale, and perspective, are used to create a sense of depth in a painting.

▲ Picnic by the river

This happy family picnic is composed so that it leads the eye easily into the scene. The closest figures are larger than those in the water, and the red of the blanket makes it appear close to the viewer.
Luke Martineau

The green door ▶

The cleverly arranged zig-zagging diagonals of the stairs and doors lead us right through the confined space, from the dominant orange shelf to the green door and the receding blue wall.
Ray Spooner

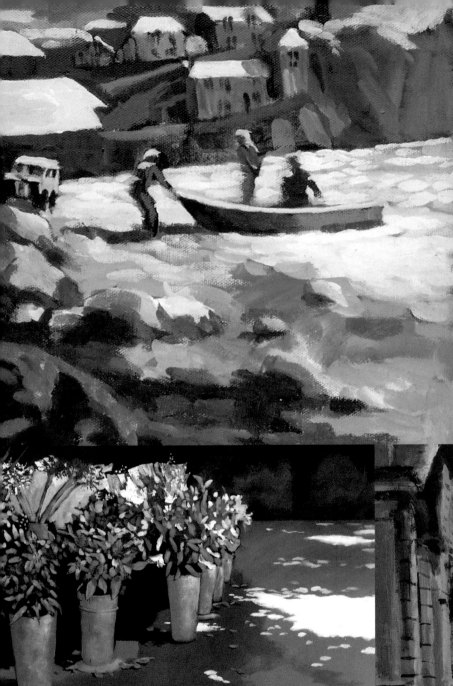

◀ Fishermen in Port Isaac

The foreground rocks are bolder, stronger, and larger than the more distant rocks. The sandy ground becomes more subdued as it gets farther away. Distance makes the houses on the hill appear blue. *Wendy Clouse*

▼ Toward the National Gallery from the Haymarket

One-point perspective is used to give the impression of depth in this busy street scene. The kerbstones in the foreground are given more emphasis than the distant kerbstones, and buildings seem to get smaller and closer together as they recede. *Nick Hebditch*

▲ Flower market, Provence

The flowers and their containers appear to get smaller as they curve into the distance. The display in the foreground is stronger, larger, and more defined. The near shadow covers more area and is richer in color than the distant shadow. *Clive Metcalfe*

◀ Ancient highway

Linear perspective has been used in this rural scene to give an impression of depth. The road narrows as it disappears into the distance. The fence, gate, and telegraph poles are larger and a stronger color in the foreground. The color of the distant buildings is reduced to soft blue-gray. *Clive Metcalfe*

7 Canal at sunset

Painting an atmospheric, glowing sunset is not as difficult as it might appear. To create the mood in this painting, the whole of the paper is first underpainted with warm yellows. A soft orange, graded glaze over the top third creates a feeling of recession in the sky. Bold overlapping horizontal strokes of warm analogous color merge yellow into pink and red at the bottom of the painting. Dry brushwork and gentle sponging establish the distant trees and their reflections, while darker colors, and scratched in detail, bring the foreground into focus.

EQUIPMENT
- Acrylic paper
- Brushes: No. 10 flat bristle, No. 8 and No. 12 round, No. 1 rigger brush
- Sponge, rag, toothbrush
- Painting knives: No. 20
- Painting medium
- Cadmium yellow deep, titanium white, medium magenta, light blue, phthalo green, cadmium red light, phthalo blue, yellow light hansa, cadmium red deep

TECHNIQUES
- Reflections
- Scratching
- Dry brushwork

The warm background establishes the painting's atmosphere.

Simple dry brushstrokes suggest distant trees.

1 Scrub on a mix of cadmium yellow deep and titanium white with the No. 10 flat bristle brush. Add more titanium white, then gradually add more yellow to return to the original strength at the bottom of the painting.

2 Paint over the yellow sky, with a purple mix of medium magenta and light blue. Soften the purple with a rag. Mix light blue, medium magenta, and cadmium yellow deep and work over the water at the bottom, right to left.

3 Mix phthalo green and cadmium red light to drybrush the trees on the right. Drybrush the distant trees on the right and left with a mix of medium magenta and phthalo green. Use the first green mix for the darks on the left.

BUILDING THE IMAGE

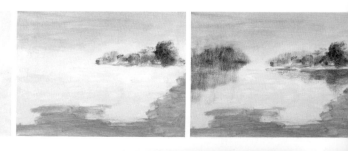

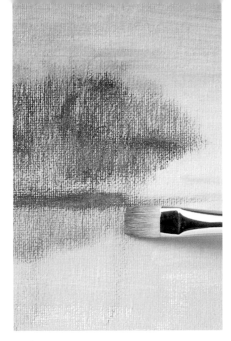
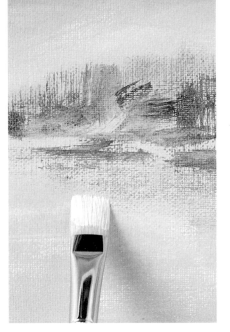
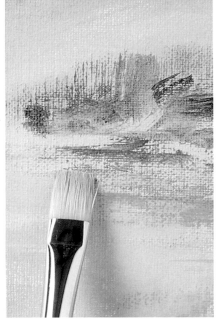

4 Mix medium magenta and light blue for the far trees. Paint the reflections of the trees with a mix of phthalo blue and medium magenta. Build up the reflections with phthalo green and cadmium red light.

5 Gently stroke the reflections with vertical strokes of titanium white to suggest the water surface. Paint cadmium yellow deep with unblended brushstrokes over the front water, so that the area appears to come forward.

6 Scumble the water surface with a mix of medium magenta, light blue, and titanium white to create the shimmer on the water on the right. Mix phthalo green and yellow light hansa to put in more reflection.

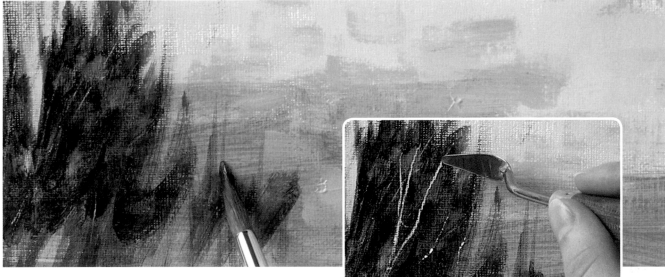
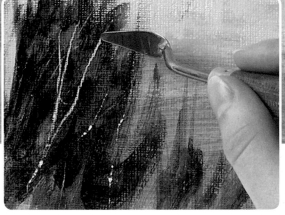

7 Use phthalo blue, phthalo green, and cadmium red light to paint the front reeds with long flicking strokes. Use the No. 20 painting knife and scrape fine vertical lines while the paint is still wet to reveal the ground color.

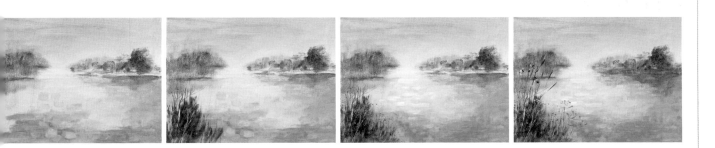

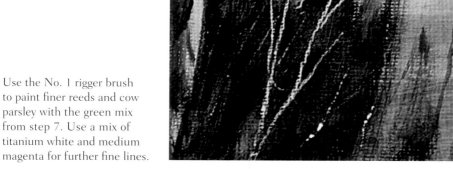

8 Use the No. 1 rigger brush to paint finer reeds and cow parsley with the green mix from step 7. Use a mix of titanium white and medium magenta for further fine lines.

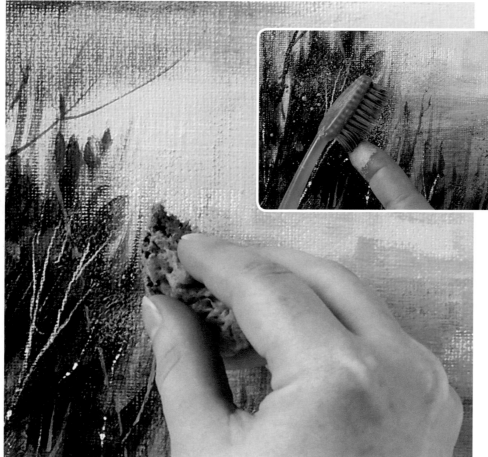

9 Dip a sponge in water and then pick up a mix of light blue and phthalo blue to gently dab among the reeds to suggest flowers and seed cases. Flick a mix of medium magenta and titanium white over the reeds with a toothbrush. Spatter a mix of phthalo blue and cadmium red light by firmly tapping the No. 8 round brush.

10 Refine the water at the front with overlapping brushstrokes of a medium magenta and titanium white mix, letting the individual strokes show. Paint the mid water with a mix of cadmium yellow deep and yellow light hansa, and toward the horizon, a mix of titanium white and light blue for recession.

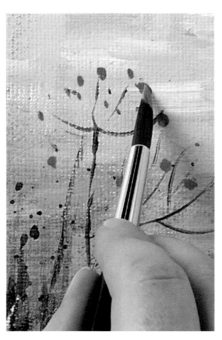

12 Paint some tall bulrushes using the No. 1 rigger brush and a mix of phthalo blue and yellow light hansa. Paint the flowers with a mix of medium magenta and titanium white using the tip of the No. 8 round brush.

11 Build up the horizon foliage and the reflections with phthalo green and painting medium. Mix cadmium red light and a little phthalo blue for the riverbank. Reduce the green on the right with phthalo green and cadmium red deep.

▼ Canal at sunset

A sense of space and recession has been created by lightening the color toward the horizon. The varied greens of the foliage have the effect of intensifying the warm orange colors.

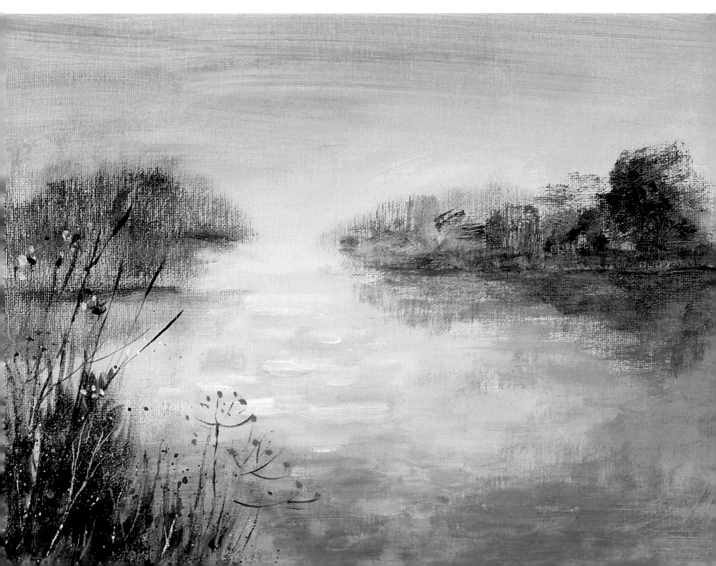

8 Steam train

This painting of a steam engine rushing toward the viewer dramatically illustrates perspective. A sense of depth is achieved through the apparent convergence of the parallel lines of the railroad track, and the train getting smaller as it disappears under the bridge. Speed and movement are realized through the use of dry brushwork, and by the swirling shape of the steam. The red of the buffer is the most dominant color, so is placed carefully in the composition using the rule of thirds. The shape of the bridge is a useful device to bring the viewer's eye back into the picture.

EQUIPMENT

- Watercolor paper—cold-pressed
- Brushes: No. 8 and No. 12 round, No. 2 flat bristle, No. 1 rigger
- Painting knives: No. 22 and No. 20
- Painting medium, texture paste
- Dioxazine purple, phthalo green, yellow light hansa, French ultramarine, titanium white, indo orange, phthalo blue, cadmium red deep, cadmium red light, cadmium yellow deep

TECHNIQUES

- Painting knife
- Creating texture
- Scratching

1 Draw in the train, track, bank, and bridge with a neutral dark mix of dioxazine purple and phthalo green, with varying quantities of each color.

2 Loosely paint trees on the left with the neutral dark mix with varying amounts of dioxazine purple and phthalo green. Add yellow light hansa to suggest the foliage in the right foreground.

BUILDING THE IMAGE

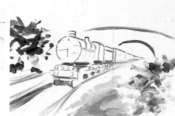
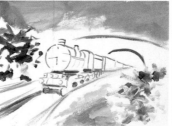
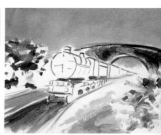

3 Scrub some of the foliage mix in the ground at the front. Create a sky mix using French ultramarine and titanium white and paint the sky with rapid, vigorous strokes using the No. 12 round brush.

4 Mix French ultramarine and indo orange for an underpainting of the track. Add titanium white to paint the left track. Paint the bridge with the neutral dark mix with added painting medium.

5 Add yellow light hansa and phthalo blue to the left foliage. Mix dioxazine purple, phthalo green, titanium white, and painting medium for the foliage shadow. Add tree height with phthalo green and dioxazine purple.

6 Paint the right bank with a sandy mix of indo orange, yellow light hansa, dioxazine purple, and titanium white. Add the sky mix for the bank that is farther away. Lighten the front with a touch of titanium white. Mix dioxazine purple, phthalo green, and painting medium for underneath foliage on the right.

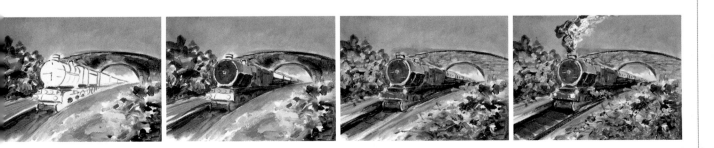

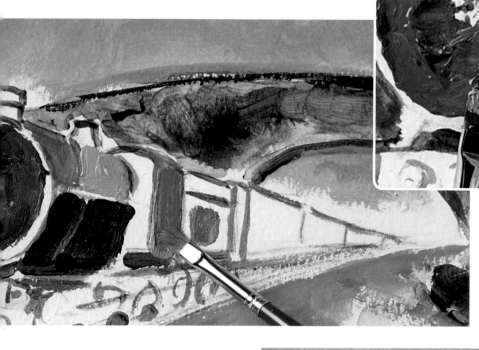

7 Paint the front of the engine with a mix of phthalo blue, indo orange, and texture paste. Mix texture paste with cadmium red deep and with titanium white to paint the reflected light on its front. Use yellow light hansa and phthalo green for the side of the train and tone down with indo orange.

8 Mix dioxazine purple, phthalo green, French ultramarine, and painting medium to create a black mix. Use this to paint under the carriage and for the shadow the train casts over the track. Lighten the cab with titanium white and French ultramarine. Paint the carriage tops with the sky mix.

9 Paint between the carriages, define them, and add wheels and windows with phthalo blue. Mix cadmium red deep and phthalo blue for the distant carriages. Add highlights of cadmium red deep with texture paste and paint their tops with indo orange, yellow light hansa, and titanium white.

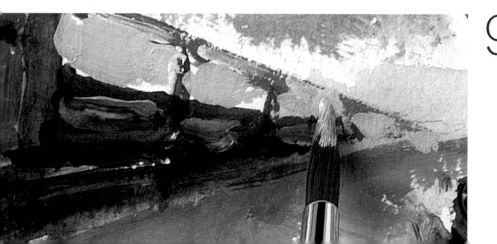

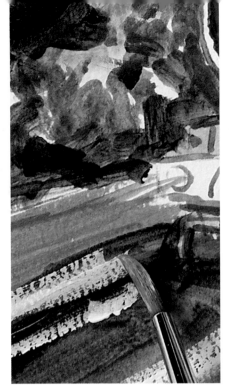

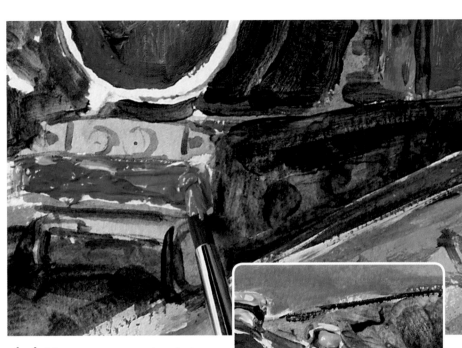

10 Use the black mix for the funnel and to redefine the track. Repaint the bank with the sandy mix. Drag titanium white over the track to refine it. Add titanium white to the black mix to paint the windows.

11 Mix texture paste with cadmium red light for part of the engine front; for the right side use indo orange and texture paint. Paint the carriage trims and funnels cadmium yellow deep, add their highlights and more trims with yellow light hansa.

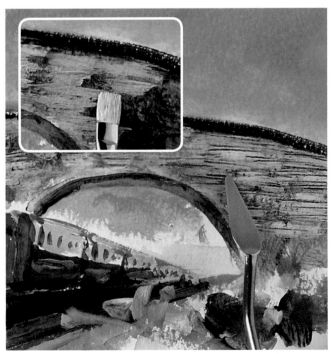

12 Add lamps and the front wheels' highlights with titanium white and suggest movement with flicked strokes over the wheels. Use French ultramarine and titanium white for trims and the warm black mix for buffers and sleepers.

13 Mix texture paste with indo orange and phthalo blue and use the No. 2 flat bristle brush to paint this on the bridge to create its texture. Scratch in with the point of the No. 20 painting knife to suggest the stonework.

14 Mix phthalo green, yellow light hansa, and cadmium red light with texture paste for left foliage. Paint right foliage with phthalo green and painting medium. Apply indo orange, phthalo green, and texture paste with the No. 22 painting knife. Use the point of the knife to scratch in branches and stems.

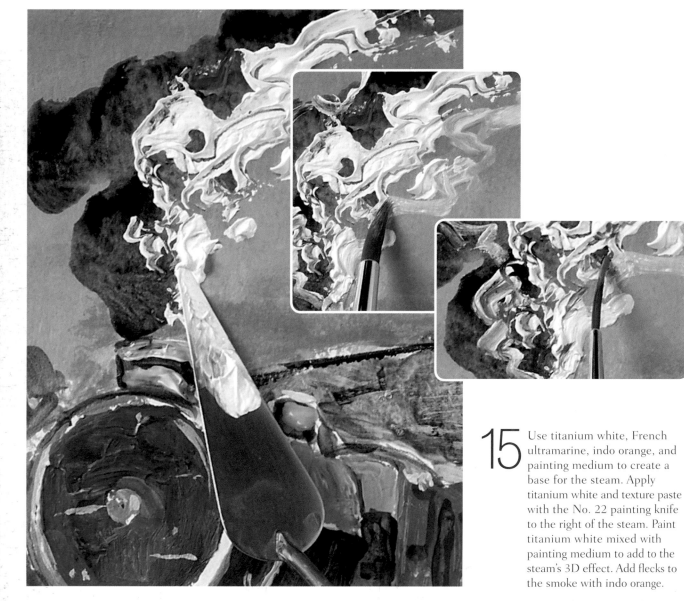

15 Use titanium white, French ultramarine, indo orange, and painting medium to create a base for the steam. Apply titanium white and texture paste with the No. 22 painting knife to the right of the steam. Paint titanium white mixed with painting medium to add to the steam's 3D effect. Add flecks to the smoke with indo orange.

16 Paint under the red of the engine, and define the track, with the black mix. Paint the sleepers indo orange and phthalo blue, and their shadow with phthalo blue and painting medium. Paint the buffers with titanium white and texture paste, and their shadow with the black mix. Flick indo orange on the foreground foliage.

▼ Steam train

Perspective is carefully created in this painting, but the precise mechanical details of the steam engine and wheels are omitted, to help underline the impression of depth, speed, and power.

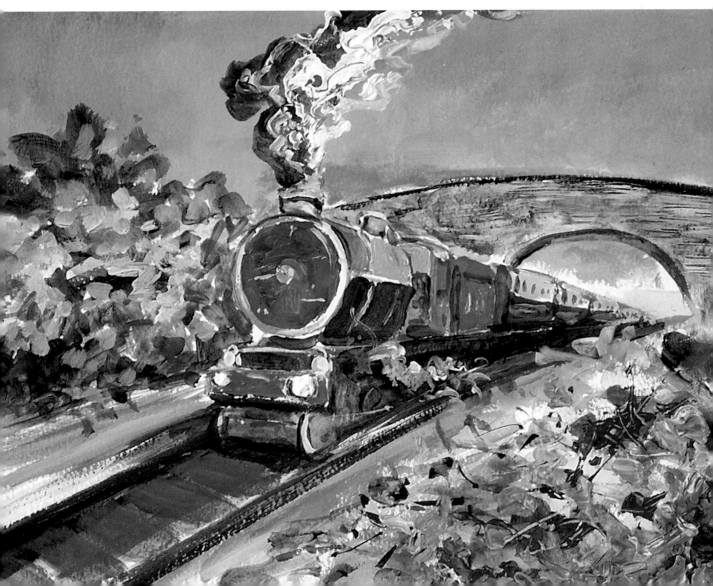

9 Teatime still life

The high viewpoint of this painting enables the viewer to look down on the tabletop and see clearly the goodies on offer. Lighting the scene from the side emphasizes the volume of the forms. The ellipses of the plates, jug, cup, and saucer, are wide open, creating bold shapes that are an important part of the composition. The angles of the napkin and the knife lead dramatically into the painting. The warm shadows link one object to another, and the green decorations on the cup cakes provide contrasting pointers, or highlights.

EQUIPMENT

- Stretched canvas
- Brushes: No. 8 and No. 12 round, No. 1 rigger
- 2B pencil
- Light blue, French ultramarine, titanium white, indo orange, phthalo blue, cadmium yellow deep, phthalo green, medium magenta, cadmium red deep, cadmium red light, yellow light hansa

TECHNIQUES

- Painting metal
- Highlights

CREATING A COMPOSITION

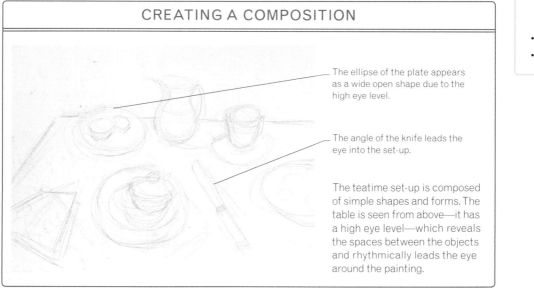

The ellipse of the plate appears as a wide open shape due to the high eye level.

The angle of the knife leads the eye into the set-up.

The teatime set-up is composed of simple shapes and forms. The table is seen from above—it has a high eye level—which reveals the spaces between the objects and rhythmically leads the eye around the painting.

Block in the main areas at the start of a painting.

1 Sketch out the scene with the 2B pencil. Block in the background with light blue, using the No. 8 round brush to carefully paint around the plate, cup, and milk jug that stand above the height of the table.

BUILDING THE IMAGE

2 Use French ultramarine and titanium white for the rims and pattern of the plates and cup. Paint inside the top left plate with titanium white. Mix a cool gray from French ultramarine, indo orange, and titanium white for shadows on the plates.

3 Use the cool gray mix to paint the shadow on the right-hand side of the jug to give it form. Use the same cool gray mix to paint the shadow inside and outside the tea cup and on the side of each of the cupcakes.

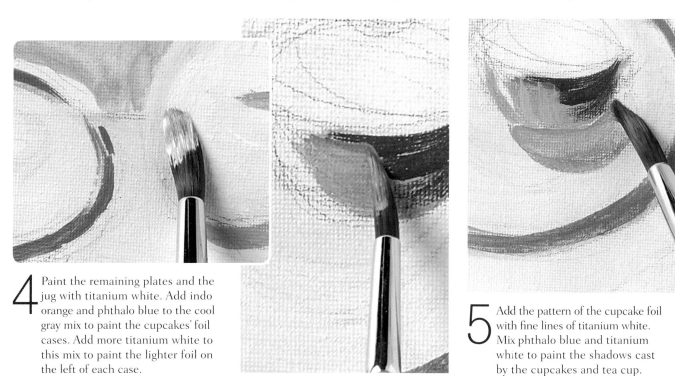

4 Paint the remaining plates and the jug with titanium white. Add indo orange and phthalo blue to the cool gray mix to paint the cupcakes' foil cases. Add more titanium white to this mix to paint the lighter foil on the left of each case.

5 Add the pattern of the cupcake foil with fine lines of titanium white. Mix phthalo blue and titanium white to paint the shadows cast by the cupcakes and tea cup.

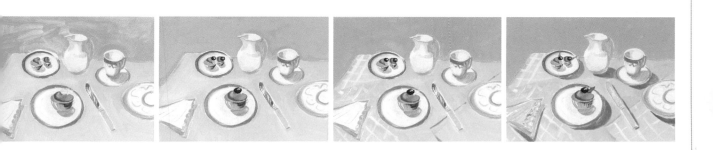

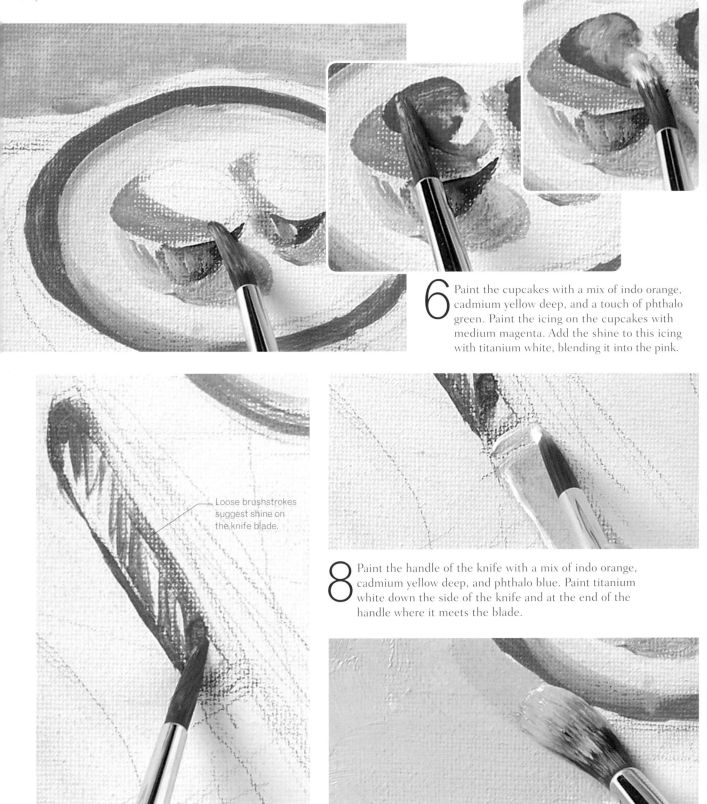

6 Paint the cupcakes with a mix of indo orange, cadmium yellow deep, and a touch of phthalo green. Paint the icing on the cupcakes with medium magenta. Add the shine to this icing with titanium white, blending it into the pink.

Loose brushstrokes suggest shine on the knife blade.

8 Paint the handle of the knife with a mix of indo orange, cadmium yellow deep, and phthalo blue. Paint titanium white down the side of the knife and at the end of the handle where it meets the blade.

7 Paint the plate and suggest the napkin with a mix of French ultramarine and titanium white. Add phthalo green and paint the knife blade, leaving areas of white where the light is reflected.

9 Paint the tablecloth with a mix of cadmium yellow deep and titanium white using the No. 12 round brush. Define the edges of the plate with this mix. The yellow of the tablecloth will draw out the violet tones in the blue.

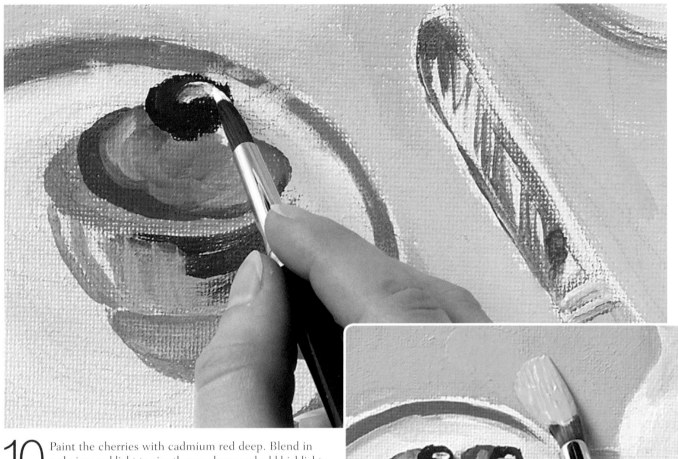

10 Paint the cherries with cadmium red deep. Blend in cadmium red light to give them a sheen and add highlights of titanium white. Paint over the background again with light blue to eliminate the individual brushstrokes and create an even background.

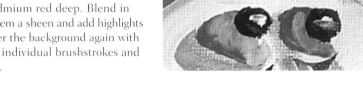

USING PATTERNS

Patterns can be used as compositional devices to create links between objects. Patterns such as checks or stripes appear to converge as they move away from the foreground, giving an impression of depth.

11 Add the check pattern on the tablecloth with titanium white, and paint folds on it with cadmium yellow deep. Mix medium magenta and cadmium yellow deep for lines of overlapping tablecloth and blend these with cadmium yellow deep.

12 Mix medium magenta, titanium white, and cadmium yellow deep to paint the napkin and the shadow on the tablecloth in the top right-hand corner. Mix medium magenta and cadmium yellow deep to paint the shadows of the objects on the tablecloth.

"Colorful shadows add shape and rhythm to a painting."

13 Paint the leaves on the cakes with a mix of phthalo green and yellow light hansa using the No. 8 round brush. Add pattern to the napkin with light blue and medium magenta.

14 Paint over the blade with light blue and titanium white to soften the reflections. Strengthen the pattern of the cupcake foil cases with thin stripes of titanium white using the No.8 round brush.

▼ Teatime still life

The clear, singing colors of this painting are luscious and mouth-watering, and a pleasure to look at. The high viewpoint and the pattern on the tablecloth add to the feeling of depth.

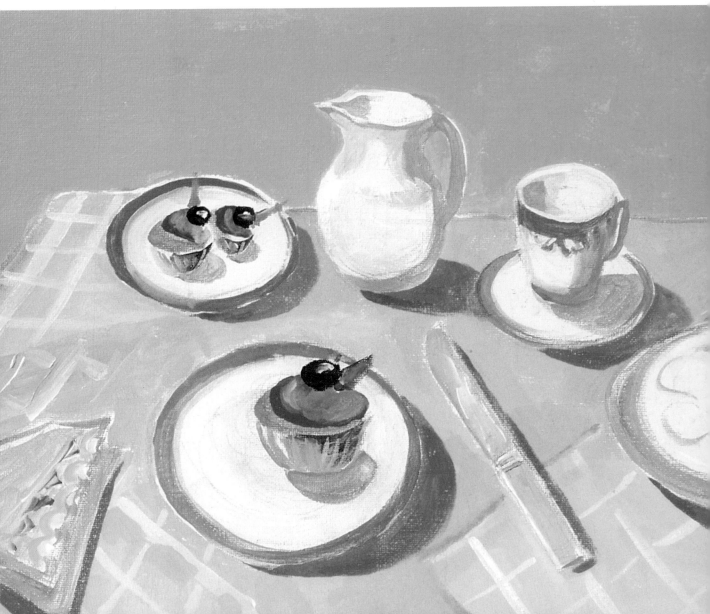

Impact

"Contrasts of color, pattern, and light and dark create impact."

Creating impact

For a painting to be considered successful, it must have impact and leave an impression on the viewer. Impact can be achieved in a number of ways. The introduction of strong diagonals into a painting will create impact through direct movement. Impact also occurs when the darkest areas of a painting are placed next to the lightest areas. An overall, rhythmic impact can be gained by painting light against dark, and dark against light, in sequence across the painting—a technique called counterchange.

USING DIAGONALS

Diagonal shapes that cut across a painting are dramatic and create dynamic movement, giving a painting impetus. Diagonals play a strong part in creating impact in the painting on the right, which shows an elderly woman walking home after a day in the fields. The tree trunk and branches form strong diagonal lines, which, along with the upward brushstrokes used to make the leaves, convey vigor and intensity. The leaning figure of the woman gives an impression of movement, emphasized by the diagonal slant to the stick in her hand.

Swift, upward brushstrokes capture the movement in the leaves.

A variety of diagonal strokes are used to depict the grasses and thicket.

Breezy evening This painting uses diagonals and strong colors to capture the power of nature.

DARK AND LIGHT

Extreme contrasts of dark and light in a painting are visually exciting and stimulating. These areas of contrast have an edge that creates immediate impact and naturally provide a focus for a painting. Creating such an area in your painting will help draw the viewer in. Underplaying the rest of the painting by limiting the range of darks and lights around the focal point means that these areas will not compete for attention and lessen the dramatic impact.

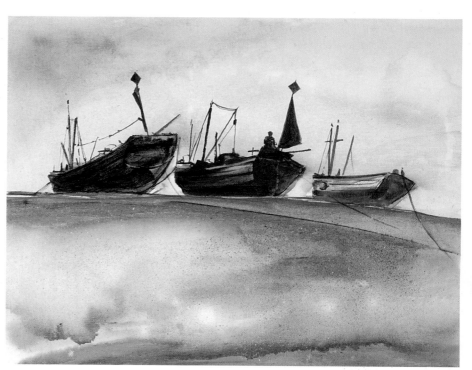

Extreme contrasts Impact is achieved through the dramatic placing of the silhouetted shapes of the fishing boats against a light sky. The undefined foreground does not intrude on the main focus of the painting.

COUNTERCHANGE

Creating adjacent areas of light and dark shapes across a painting provides impact through what is called counterchange. This technique adds impact by producing strong areas of contrast, and it helps draw the eyes across a painting from areas of light to dark and back to light again. Actual color becomes less important than the play of light and dark. Counterchange is often used in portraits, where sidelighting creates alternating highlights and shadows across the face and background, so providing extra impact.

Contrast This series of contrasting shapes shows how the positioning of very pale and dark areas next to each other creates impact.

Applying counterchange In this simple painting, the eye is drawn across from the pale blue background on the left, to areas of dark, light, and back to dark.

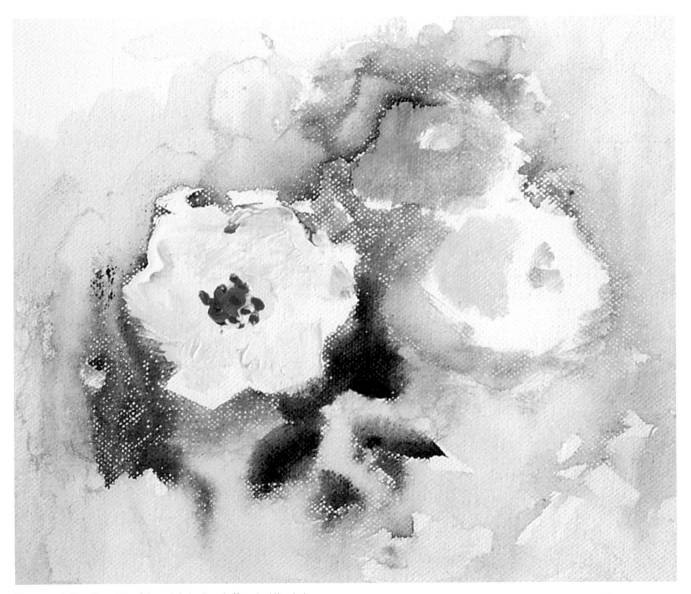

Flower painting The white of the petals is played off against the dark spaces in-between, a use of counterchange to produce impact in this otherwise very subtle painting of flowers.

Gallery

Diagonal shapes are good tools to add impact and draw the eye into a painting. Contrasts of light and dark can also bring a painting to life.

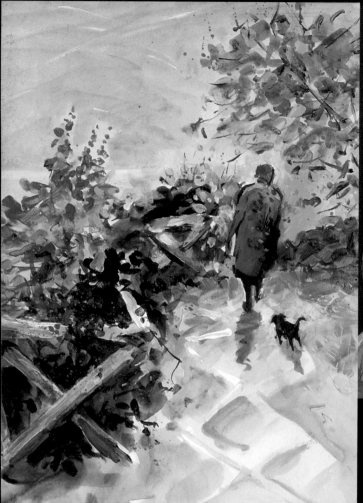

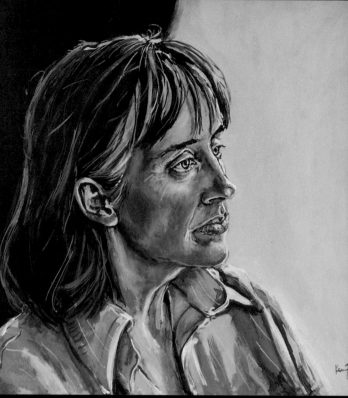

▲ Mrs. Harris
The impact of this portrait is created by the dynamic contrast of dark and light in the background. The diagonal lines that run along the blouse and neck lead the viewer's eye into the painting. *Ken Fisher*

▲ Walking the dog
The diagonals of the fence lead the eye into the scene. Counterchange is used for the patterning of the paving, and the red hat against the blue-green of the foliage adds impact. *Phyllis McDowell*

School ▶
This painting shows the dynamic use of diagonals. The fish swimming in from the top left are in opposition to the main school of fish swimming in from the top right. Color contrast adds sparkle and impact. *Lindel Williams*

◄ Feeling the fabric

A limited palette has been selected for this intimate painting of a cluster of girls. The way in which the lights and darks have been distributed over the paint surface gives visual impact. This is an example of counterchange.
Vikky Furse

▼ Spindrift

The strong diagonal and interesting patterning of the breakwaters leads the eye into the painting. The sea in the foreground forms an opposing diagonal driving force to the composition.
Ken Fisher

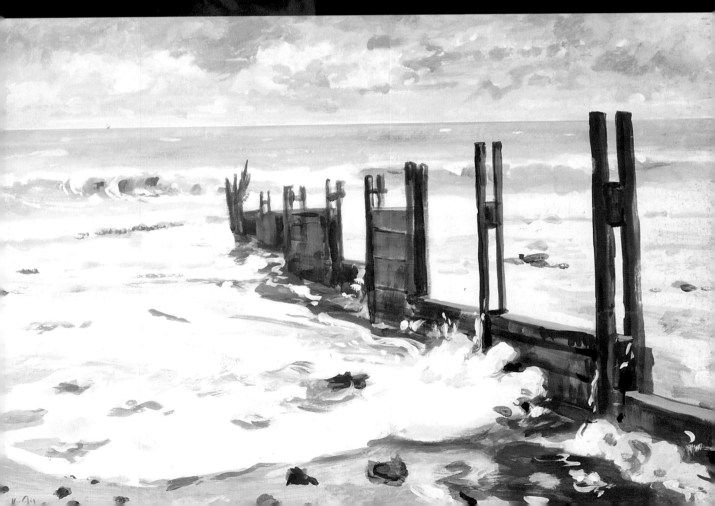

10 Cherry tree in blossom

Dynamic, vigorous brushstrokes, depicting the branches of a tree, flow in from the left in this vibrant painting of cherry blossom, thrown forward into relief by the bright blue sky behind. Dark leaf shapes are applied to give depth, and a variety of green marks are added to suggest foliage flickering in the light. Scrumptious dollops of pink, violet, and white are mixed with texture paste and applied, almost at random, with the painting knife to create the blossoms and buds. To add sparkle and give breathing space, flecks of the white ground are left untouched.

EQUIPMENT
- Stretched canvas
- Brushes: No. 2, No. 6, and No. 8 flat bristle, No. 12 round, No. 1 rigger
- Painting knives: No. 22
- Texture paste
- Phthalo blue, cadmium red light, titanium white, phthalo green, cadmium red deep, cadmium yellow deep, yellow light hansa, dioxazine purple, medium magenta, indo orange, light blue

TECHNIQUES
- Painting knife
- Texture paste
- Layering

SKETCHING WITH PAINT

When starting a painting, you can draw directly onto the canvas or paper with brush and paint. This fluid approach, which eliminates mapping out the composition in pencil or charcoal, gives the painting immediate impact, vitality, and movement.

1 Sketch out the position of the branches using the No. 2 flat bristle brush and phthalo blue. Mix a dark from cadmium red light with the phthalo blue to add variety to the color of the branches. Use this mix too to suggest where the leaves are.

BUILDING THE IMAGE

2 Paint the sky with a mix of phthalo blue and titanium white, using the No. 8 flat bristle brush and vigorous. multi-directional strokes. Add more titanium white to paint the lower part of the sky, creating a gradient from dark to light, which increases the feeling of space.

3 Thicken the lines of the branches that are closest to the tree with the first dark mix. Taper them off at the ends. Paint some leaves with phthalo green using the No. 6 flat bristle brush. Add more leaves using a mix of phthalo green and cadmium red deep.

4 Paint cadmium red deep over the white canvas where the cherry blossom is using the No. 12 round brush and calligraphic strokes. Use cadmium red deep and phthalo green for the background leaves, with no light shining on them, using the No. 6 flat bristle brush.

5 Add some cadmium red light and increasing amounts of cadmium yellow deep to the background leaf mix. Use these mixes over both the dark greens and the white canvas to create further variety.

IMPASTO

Impasto is a method of applying paint to give a rich quality to the paint surface. Color is put on thickly and directly using a flat bristle brush or a painting knife.

6 Continue building up the leaves. Mix phthalo green and yellow light hansa to paint the leaves that are catching the light. Mix yellow light hansa with a hint of phthalo green to paint the lightest leaves in the sunlight.

7 Paint the dark left corner with a mix of phthalo green and cadmium red deep. Paint lighter areas on the blossoms using cadmium red deep and titanium white with individual brushstrokes.

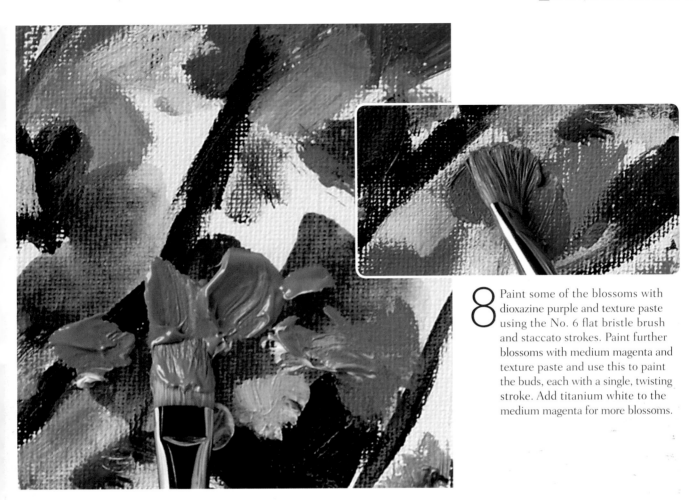

8 Paint some of the blossoms with dioxazine purple and texture paste using the No. 6 flat bristle brush and staccato strokes. Paint further blossoms with medium magenta and texture paste and use this to paint the buds, each with a single, twisting stroke. Add titanium white to the medium magenta for more blossoms.

9 Knock back the white around the blossoms with a mix of phthalo blue and titanium white to help create a rich background. Fill in the far left branches with phthalo green and cadmium red deep and add a few more at the top left.

10 Add some more leaves over the new branches with a mix of phthalo green and cadmium yellow deep and use this mix elsewhere to add richness to the foliage. Paint the tops of the branches that are in the light with titanium white using the No. 1 rigger brush.

11 Mix yellow light hansa and titanium white to add shine to the leaves with calligraphic strokes. Stroke indo orange on top of some of the white on the branches with the No. 1 rigger brush. Paint on top of other white areas on the branches with light blue.

12 Apply dioxazine purple and texture paste to the blossoms and buds using the point of the No. 22 painting knife. Repeat with medium magenta and texture paste. Use yellow light hansa and texture paste and the point of the painting knife to add small dots that suggest stamens.

▼ Cherry tree in blossom

These branches, laden with cherry blossom, express the vitality of nature. Setting the riot of blossom color, and varying shades of green foliage, against a bright blue sky throws them forward and gives the painting impact.

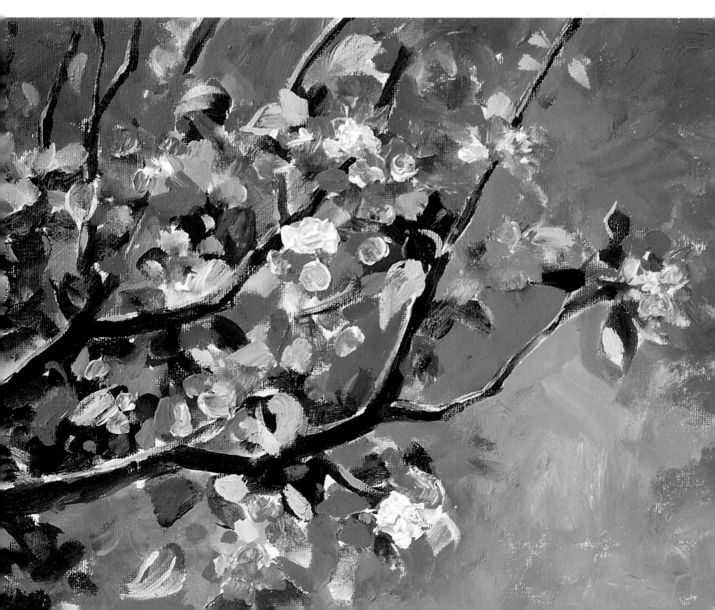

[11] Boat on the beach

This painting re-creates the lively environment of a working beach, with the fisherman standing by his boat working at his net, surrounded by the tools of his trade. The spontaneous feel is partly achieved by leaving areas of watercolor paper uncovered, and the sky is merely hinted at. The paraphernalia on the beach is suggested, rather than defined, through the use of sponging, spattering, scratching, and wax resist. The jaunty angles of the flagpoles, ladder, and rope provide impact, and the flags painted with one brushstroke convey movement.

EQUIPMENT

- Watercolor paper—cold-pressed
- Brushes: No. 8 and No. 12 round, No. 1 rigger
- Wax candle, cardboard, toothbrush, kitchen paper
- Phthalo blue, cadmium red light, cadmium red deep, cadmium yellow deep, medium magenta, light blue, French ultramarine, titanium white, phthalo green, indo orange

TECHNIQUES

- Resist
- Painting on posterboard
- Putting in a figure

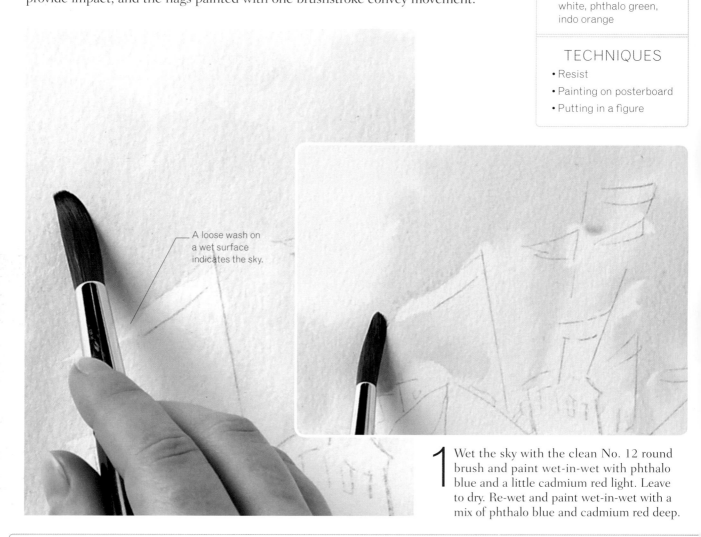

A loose wash on a wet surface indicates the sky.

1 Wet the sky with the clean No. 12 round brush and paint wet-in-wet with phthalo blue and a little cadmium red light. Leave to dry. Re-wet and paint wet-in-wet with a mix of phthalo blue and cadmium red deep.

BUILDING THE IMAGE

The application of candle creates a textured effect.

USING WAX CANDLE

A resist repels paint and is used to preserve areas of white paper or underlying color. To use wax for a resist, cut a household candle to 1–2 in (12.5–25 mm) in length, slice lengthwise, and remove the wick.

2 Draw into the foreground with the wax candle where there is netting and pebbles to create a resist, which will retain the white of the paper. Press firmly when using the candle.

3 Wet areas of the beach with a clean brush, then paint with cadmium red light, cadmium yellow deep, and a mix of these two. Paint the boat and fisherman with a mix of cadmium yellow deep and medium magenta.

4 Paint the sea with a graded wash of light blue, French ultramarine, and titanium white using the No. 12 round brush. Add a wash of light blue, phthalo blue, and cadmium red light over the front part of the boat in the shade, the cabin, and the containers.

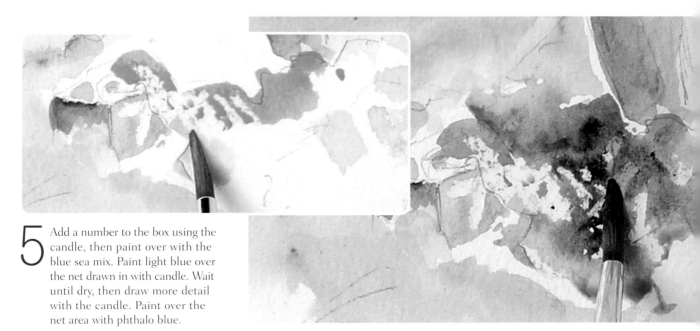

5 Add a number to the box using the candle, then paint over with the blue sea mix. Paint light blue over the net drawn in with candle. Wait until dry, then draw more detail with the candle. Paint over the net area with phthalo blue.

6 Paint a gray wash of phthalo blue and cadmium red light over the figure. Draw in the ladder with the candle, then paint the gray wash over this area to create the shadow cast by the ladder on the boat.

7 Paint the net with phthalo green and light blue. Add texture to the boat by drawing on with the candle then painting over with phthalo blue. Paint the fisherman's cap and arm with the gray mix and his overalls indo orange.

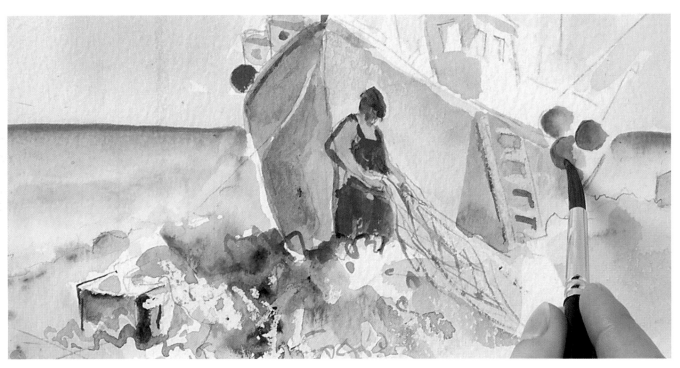

8 Paint the shadow under the net, and the boxes and debris on the beach, with the gray mix. Paint medium magenta at the base of the boxes and use it to put in the detail of the buoys. Add detail to the back of the boat with light blue.

9 Cut a piece of posterboard the length of one of the boat's flagpoles. Paint the edge of this board with the gray mix. Press the painted edge onto the painting to create the straight lines of the boat's flagpoles, giving each of them a crisp printed line.

10 Paint two flags black with a mix of phthalo green, phthalo blue, cadmium red deep, and cadmium red light using the No. 8 round brush and one pressurized stroke. Paint other flags indo orange and cadmium red deep.

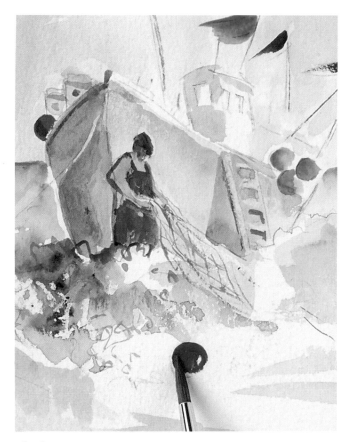

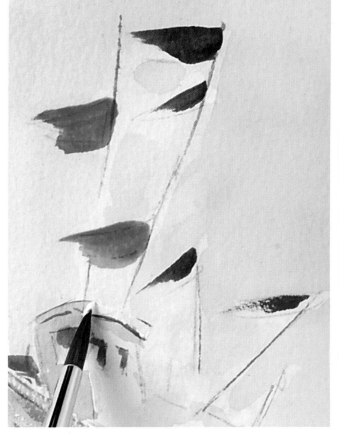

11 Paint cadmium red deep over the front buoy on the boat and add a buoy to the beach with a pink mix of cadmium red deep and medium magenta. Paint the edges of the boat and buoys with the gray mix.

12 Paint the prow indo orange and add touches of titanium white to the cabin. Draw the candle on the box to the right of the boat and paint over with the gray mix. Add more buoys next to this box with the pink mix.

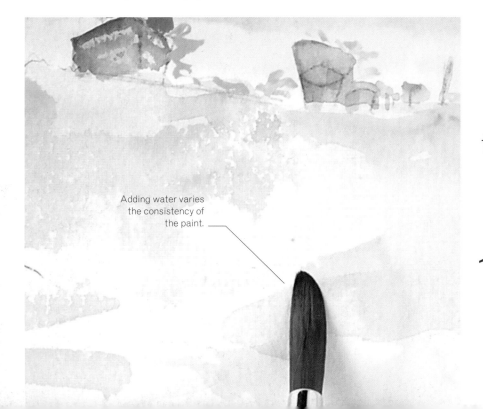

Adding water varies the consistency of the paint.

"The movement in the flags gives the impression of a breezy day."

13 Mix watery light blue for the foreground and right of the beach. Add diluted titanium white to the fisherman's hat and use titanium white to paint his sleeves and add highlights on the buoys. Add detail to the beach with light blue.

14 Wet areas of beach, then paint wet-in-wet with phthalo green. Add lines of gray mix to the flags. Cover the painting with paper towel, leaving part of the beach exposed, and flick over indo orange with a toothbrush and with the No. 8 round brush. Define the edge of the beach with indo orange and paint the rope with the gray mix.

▼ Boat on the beach

The light coming from the right creates counterchange patterns on the boat, and this, along with the use of diagonals, creates impact. The dynamic triangle of the red buoys is designed to move the eye around this beach scene.

12 Portrait of a young woman

A portrait painting can be one of the most challenging subjects for an artist to undertake, but the beauty of using acrylics is that it is simple to adjust areas that you are not happy with. The main aim in this portrait is to illustrate form in a simple way. The head is seen as a cube and the neck as a cylinder. In this instance, the head is turned slightly to one side so that both the front and the side planes can be seen. The front of the face and neck, and the top plane of the nose, are illuminated, whereas the side planes of each are in shadow.

EQUIPMENT

- Stretched canvas
- Brushes: No. 8 round, No. 10 flat bristle, No. 1 rigger
- Charcoal stick, paper towel, painting medium
- Titanium white, cadmium yellow deep, indo orange, phthalo blue, cadmium red deep, phthalo green, French ultramarine, light blue, cadmium red light, medium magenta

TECHNIQUES

- Proportion
- Creating form

PROPORTIONS

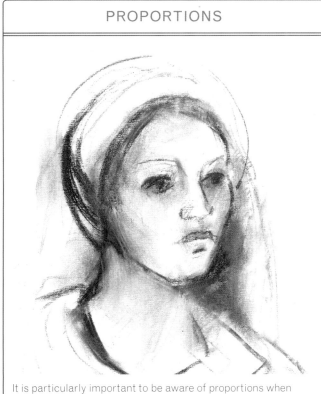

It is particularly important to be aware of proportions when working on a portrait. The measurements of the forehead, nose, mouth, and chin have to be correct in relationship to each other in order to create a convincing likeness.

1 Draw the face with a charcoal stick, putting in the main shadows that show the direction of the light. Establish the tonal range with the charcoal, removing it in places with paper towel to create highlights and soft mid-tones.

BUILDING THE IMAGE

2 Indicate some background on the left, with a mix of titanium white, cadmium yellow deep, indo orange, and phthalo blue, using the No. 10 flat bristle brush. Add more phthalo blue to indicate the darker areas of the face and headscarf.

3 Blend the dark areas with a clean, wet brush. Draw in the features with phthalo blue. Put a watery mix of phthalo blue on the right and soften all areas of the face with a pink mix of indo orange, titanium white, and cadmium red deep.

4 Add more cadmium red deep to the pink mix for the lips; and phthalo green for the shadow area. Add indo orange and titanium white to the mix to paint the mid-tones. Add more cadmium red deep to the mix to define the lips.

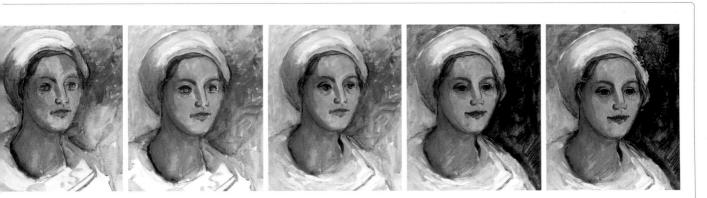

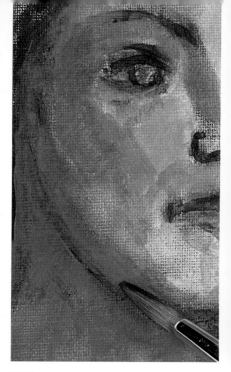

5 Paint the right background with phthalo blue and, while wet, add French ultramarine. Add titanium white for the left background. Sketch in the shoulder with French ultramarine. Add right shadow with a phthalo blue and indo orange mix.

6 Build up the thickness of the paint in the background with a layer of phthalo blue and French ultramarine. Add titanium white, then paint the left background. Mix indo orange and cadmium red deep to put in wisps of hair around the face.

7 Mix indo orange, cadmium red deep, and titanium white for the face in shade. Soften the edge of the face with phthalo green and titanium white. Paint titanium white and phthalo blue to the left of the head and on the headscarf in shade.

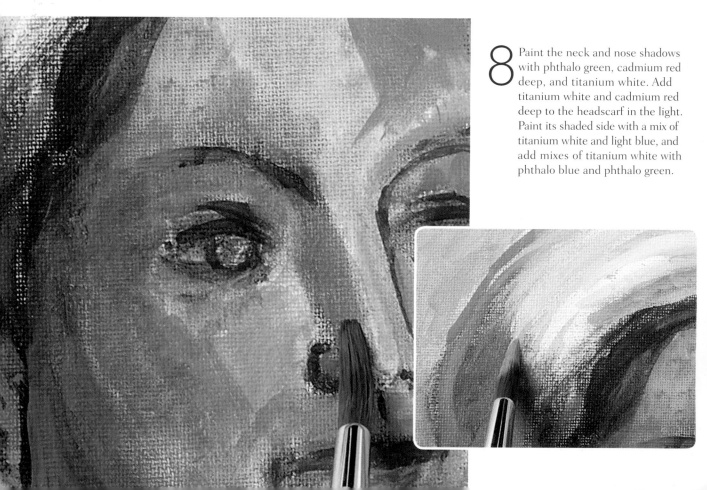

8 Paint the neck and nose shadows with phthalo green, cadmium red deep, and titanium white. Add titanium white and cadmium red deep to the headscarf in the light. Paint its shaded side with a mix of titanium white and light blue, and add mixes of titanium white with phthalo blue and phthalo green.

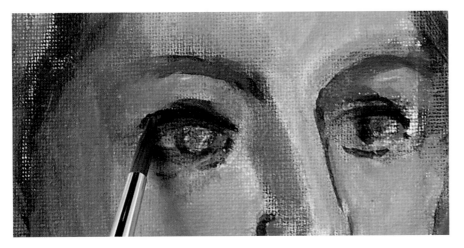

9 Paint parts of the face that are in the light with a mix of indo orange, cadmium red deep, titanium white, and phthalo blue. Define the eyes with a warm dark mix of phthalo blue, phthalo green, and cadmium red deep. Add titanium white to put the shadow under the eye.

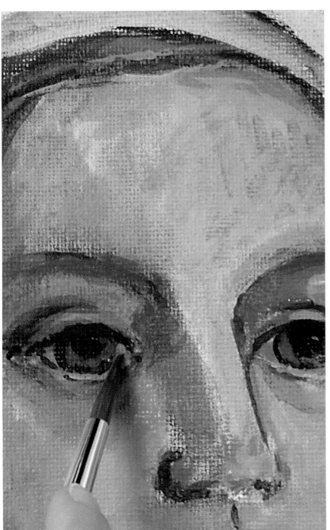

"Knowledge of perspective is helpful in painting convincing portraits."

10 Put titanium white and a touch of cadmium red deep on the lower eyelid. Paint the irises with phthalo blue, phthalo green, a little cadmium red deep, and titanium white. Use the warm dark mix to paint the pupils and titanium white and phthalo blue for the whites.

11 Paint the dress with a mix of phthalo green, cadmium red deep, and titanium white. Define the edge of the neckline with a mix of phthalo green and cadmium red deep. Paint other areas of the dress with titanium white with a touch of phthalo green.

12 Paint highlights on the hair with a mix of cadmium yellow deep, cadmium red light, and titanium white, using the point of the No. 8 round brush. Strengthen the shadow hair color with cadmium red deep and phthalo blue.

13 Raise the corner of the lips using the warm dark mix. Paint the background with cadmium red light, French ultramarine, and painting medium. Add fine lines of hair with a mix of cadmium yellow deep, indo orange, and phthalo blue.

14 Paint the flower with thick dabs of medium magenta, indo orange, cadmium red light, and cadmium red deep. Ground the flower with French ultramarine where it meets the headscarf. Add streaks of a mix of medium magenta and titanium white and of light blue to liven up the headscarf.

Portrait of a young woman ▶

The use of counterchange, light against dark, and dark against light, adds impact to this portrait. The warmth of the flesh tones and the rich, decorative flower appear vibrant against the areas of blue.

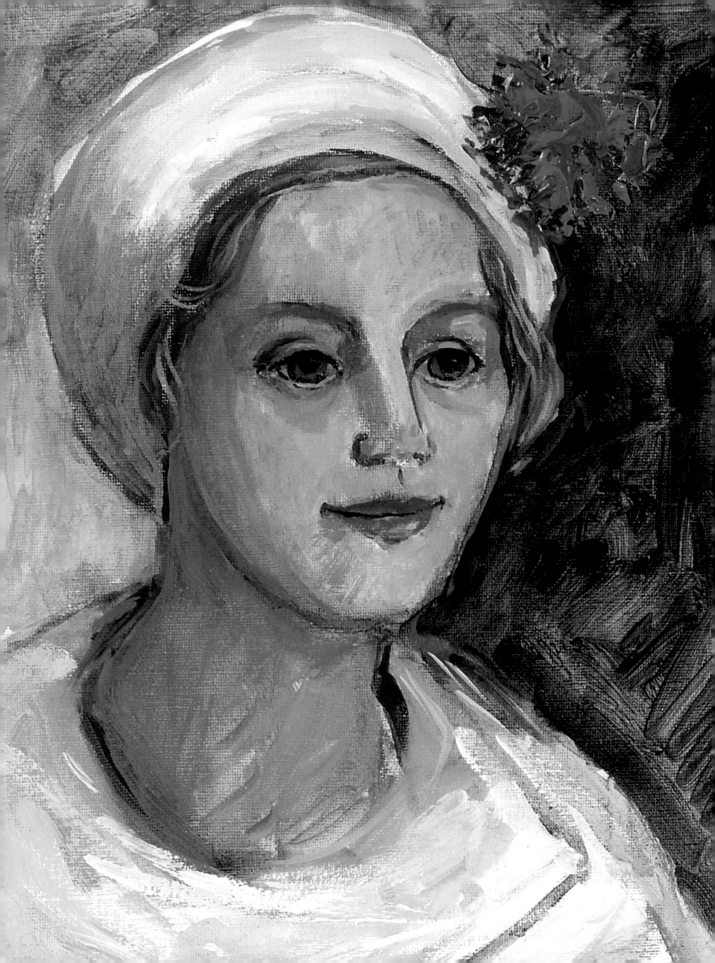

Glossary

Aerial perspective
The impression of distance achieved by reducing the warmth of colors. Objects in the distance take on a cool blue hue; those in the foreground appear more warm and intense.

Analogous colors
Colors that are closely related and next to each other on the color wheel—such as yellow and orange. Such colors mix together visually to give an overall impression of warmth or coolness.

Backlighting
Lighting created when the light source is behind the subject. Backlighting creates a silhouette and eliminates most surface detail.

Blending
A soft, gradual transition from one color to another created by stroking the paint with a brush or painting knife.

Calligraphic strokes
Rhythmic, fluid strokes and expressive lines that are drawn with a brush.

Color wheel
A visual device for showing the relationship between primary, secondary, and intermediate colors.

Complementary colors
Colors that are located directly opposite each other on the color wheel. The complementary of any secondary color is the primary color—red, blue, or yellow— that it does not contain. Green, for example, is mixed from blue and yellow, so its complementary is red.

Composition
The arrangement of various components, including the main areas of focus and balance of interest, to create a harmonious painting.

Cool colors
Blue, or colors with a hint of blue. Cool colors appear to recede in a painting, so can be used to help create depth.

Counterchange
Repeated pattern of light and dark shades that are placed next to each other to create interesting contrasts that help give impact to a picture.

Depth
The illusion of space and distance, which is achieved through color relationships, perspective, and scale.

Dry brush
Virtually dry paint dragged across the paper or canvas to produce textured marks, either directly onto an unpainted surface or on top of an existing paint layer.

Form
The solid shape of an object as seen from all possible angles and viewpoints.

Focal point
A point of interest in a painting where extreme contrasts of light and dark meet, or where the color is the

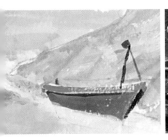

most intense. A painting should have one or more focal points to draw the eye in.

Format
The shape and proportion of the painting support, usually rectangular or square. A wide rectangle is generally known as landscape format; a rectangle that is taller than it is wide is known as portrait format.

Frontlighting
Light that shines directly on the front of the subject to reveal its true color, detail, and texture.

Glazing
The application of a transparent layer of paint over a layer of paint that has been allowed to dry completely. The colors of the first layer show through the second layer of paint and create a new, shimmering color.

Hard edge
A style of painting that produces clearly defined forms and clean contours. The color is kept flat.

Highlight
The lightest tone in a painting, occurring on the most brightly lit part of a subject.

Horizon line
In linear perspective, the imaginary line at eye level where horizontal lines meet at the vanishing point. The true horizon line, where the land meets the sky, may be higher or lower than your eye level.

Hue
Another word for color, generally used to mean the strength or lightness of a particular color.

Impasto
A technique where paint is applied thickly with the brush or painting knife to create a textured surface. The marks of the brush or knife are evident and these add interest to the composition. The term is also used for the results of this technique.

Intermediate colors
Colors that appear between the primary and secondary colors on a color wheel. They are made by mixing primary colors and secondary colors together.

Landscape format
Paint support—such as canvas, paper, or board—that is rectangular in shape and is wider than it is high. This format was traditionally used for painting large-scale landscape paintings.

Layering
Painting one color over another color that has been allowed to dry. Unlike with glazing, the colors used can be dark and opaque, so that the under layer of paint does not show through the layer of paint that covers it.

Linear perspective
Parallel lines appear to converge at a point on the horizon or eye level, called the vanishing point.

Neutrals
Colors produced by mixing two complementary colors in equal proportions. By varying the proportions of the complementary colors, a range of semi-neutral grays and browns can be made. These are more luminous than ready-made shades.

One-point perspective
Parallel lines, such as those formed by a road or path, are at right angles to a picture plane and meet at a single vanishing point on the horizon.

Opaque
Color that is impervious to light, which obscures anything underneath; the opposite of transparent. Opaque paints obscure the colors they are painted over. When opaque paints are mixed together, the results are dull.

Paint support
The paper, canvas, or board that forms the surface that is painted on.

Painting medium
A product that can be mixed with the paint to increase fluidity and enhance glazes.

Palette
A mixing area for paint, or a range of selected colors used by a particular artist or for a particular painting.

Perspective
The method of creating a sense of depth on a flat surface. This can be achieved through the use of color, scale, and linear perspective.

Portrait format
Paper in the shape of a rectangle that is taller than it is wide. It was traditionally used for standing portraits.

Primary colors
The three colors that cannot be mixed together from other colors: red, yellow, and blue. Any two of these colors can be mixed together to make a secondary color.

Proportion
The relative measurements of one object, such as the height compared with the width, or the relative measurement of one area to another.

Recession
Movement from near distance through to far distance. Color recession is the use of warm and cool colors to create the sense of depth in a painting.

Rigger
A long, fine brush that is used for detailed work.

Resist
A method of preserving highlights on white paper or a particular color by applying a material that repels paint. Materials that can be used as resists include masking fluid, masking tape, and wax.

Rule of thirds
An aid to composition, which divides a picture into thirds horizontally and vertically to make a grid of nine squares. Points of interest are placed on the "third" lines and the focal point is positioned where two lines intersect.

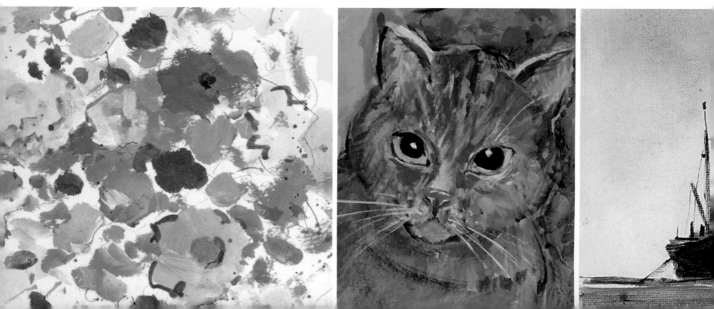

Scale
Objects that are the same size appear to get smaller the more distant they are. For example, two same-sized buildings appear to be different sizes depending on their distance from the viewer.

Scratching
Scraping off paint with a painting knife to reveal the color below.

Scumbling
Dragging a dry brush lightly loaded with opaque paint over a dry, painted area so that patches of the color underneath show through.

Secondary colors
Colors that are made by mixing together two primary colors—red, yellow, and blue.

There are three secondary colors: orange, created by mixing yellow with red; purple, made when red and blue are mixed together; and green, which is made by mixing blue with yellow.

Sidelighting
Light that shines on the side of the subject, either sunlight or from an artificial source, which reveals shape and creates both light and dark areas on the subject.

Spattering
Flicking paint from a loaded paintbrush or toothbrush to produce texture or to modify areas of the composition.

Sponging
A technique whereby a sponge is dipped into wet paint and then dabbed onto the painting to create a mottled effect that is good for texture.

Stay-wet palette
A manufactured palette that is designed specifically for use with acrylic paints. It has a damp layer under the main mixing surface to keep paints moist while being used.

Texture paste
A painting medium that is added to the acrylic paint to build up heavy impasto—or raised—textures.

Tone
The relative lightness or darkness of a color. The tone of a color can be altered by diluting it with water or mixing it with white paint or with a darker pigment.

Translucency
Clear, transparent effect, achieved by adding water to the paint.

Vanishing point
The point at which parallel lines appear to converge at the horizon line.

Viewfinder
A framing device that can be used to show how a subject will look in a variety of compositions before painting. A simple viewfinder can be made by cutting a rectangular hole in a piece of posterboard.

Warm colors
Colors with a reddish or orange tone. Warm colors appear to come forward in a painting and can be used to help create a sense of depth.

Index

Acknowledgments

Dorling Kindersley would like to thank: Simon Murrell for design help; Janet Mohun and Matthew Rake for editorial help; Sarah Hopper for picture research; Simon Daley for jacket series style; Ian Garlick for jacket phototography.

Design Gallery would like to thank: Juliette Norsworthy and Kate Clarke for design; Geraldine Christy for proofreading and additonal editorial support; Ursula Caffrey for indexing.

PICTURE CREDITS

Key: t=top, b=bottom, l=left, r=right, c=center

p.42: Private Collection/www.bridgeman.co.uk (bl);
p.43: Private Collection/www.bridgeman.co.uk (t);
p.60: Private Collection/Will's Art Warehouse/
www.bridgeman.co.uk (t), Private Collection/
www.bridgeman.co.uk (b); *p.80*: Private Collection,
© Panter and Hall Fine Art Gallery, London/
www.bridgeman.co.uk (tl).

All jacket images © Dorling Kindersley.